THE
CATS OF CUBA

by Emmy Park

SCHIFFER
PUBLISHING

4880 Lower Valley Road · Atglen, PA 19310

FOREWORD

By Hatzel Vela | Cuba Correspondent | Journalist

When it was announced the United States and Cuba were on a path to renewing an old friendship, part of the approach to improve relations was to allow more Americans to travel to the once-forbidden island. It is that interaction that would create a connection between the people of two countries who for decades played political foes on the world stage. It presented an opportunity that would ultimately lift the decades-old veil of secrecy and allow Cubans to experience the American spirit firsthand, but was also a chance for Americans to immerse themselves in Cuban culture, art, music, food, and history.

Since then, Emmy Park has done all that and more! This talented photographer first arrived in Havana in 2015, first documenting the Cuban skateboarding scene. But she took it a step further. Park knew her lens could bring the world an often-unnoticed side of Cuba. Her work has culminated in an unforgettable and heartwarming tour of Cuba's different provinces and its *mascotas*. Whether you love cats or dogs, this book shows you the Caribbean island through the eyes of its most vulnerable creatures, which often stand quietly in the background of Cuba's complex past and present. Park delivers a compilation of jaw-dropping photographs where you can palpably feel the realities that remind us that while humans struggle, it is their furry loved ones that take the brunt of the surrounding human condition and its reality.

After you're done flipping through its pages, this book is bound to become a classic for any animal lover who may also want to escape to a country once hardly accessible to Americans. It will touch your heart!

INTRODUCTION
By Emmy Park

I traveled to Cuba for the first time in April of 2015. I knew very little of the country, except from what I had read and seen in films. I immediately noticed cats everywhere, on each street corner. I learned that there are no laws for the protection of domestic animals in Cuba, thus leading to the abuse and abandonment of cats.

In this book, I welcome you to journey along with me from eastern to western Cuba. While traveling through various cities and towns and ultimately arriving on Isla de la Juventud, I will share my exploration into the lives of Cuba's cats and their human caregivers. You may sometimes see a cat wearing *la tira roja* (the red ribbon), which represents the Yoruba Orisha Shango (God of Thunder) and is believed to be a protection against evil.

Through social media, I connected with animal rescue organizations in Cuba and decided to use my photography to raise awareness for the plight of the cats in Cuba. With the help of followers on social media and local supporters, every time I travel to Cuba I bring as many medical supplies, collars, leashes, toys, and cat food as I can carry to donate to the local animal rescue volunteers. My hope is that after seeing these images you will feel inspired to join this movement in helping the cats of Cuba.

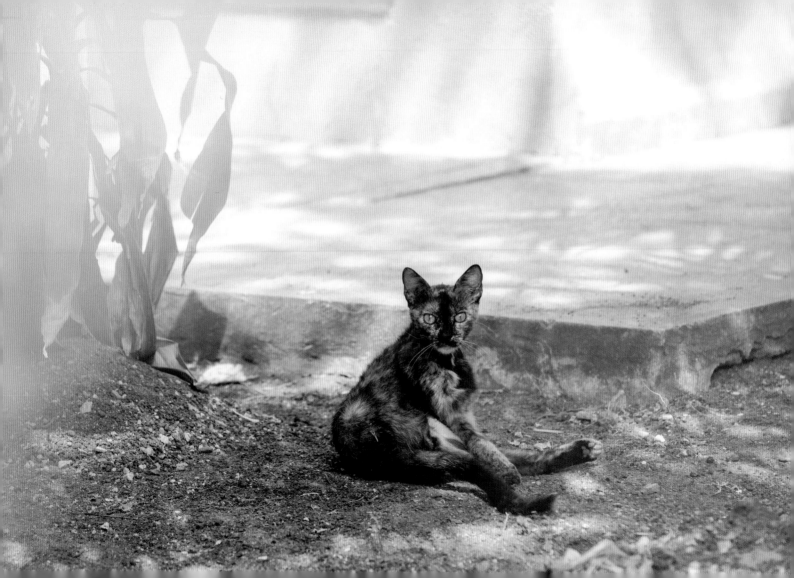

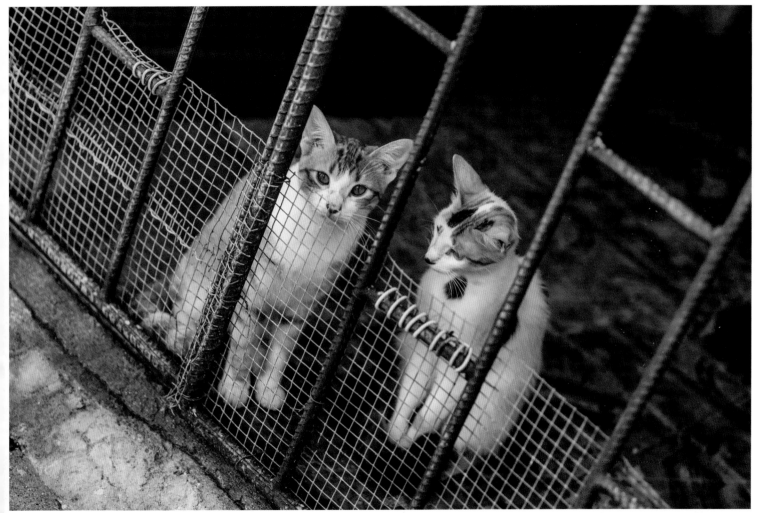

Santiago de Cuba, Santiago de Cuba

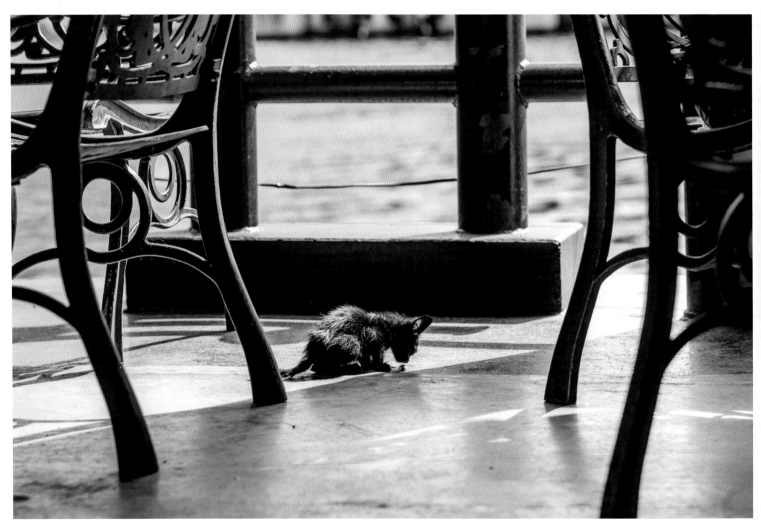

Santiago de Cuba, Santiago de Cuba

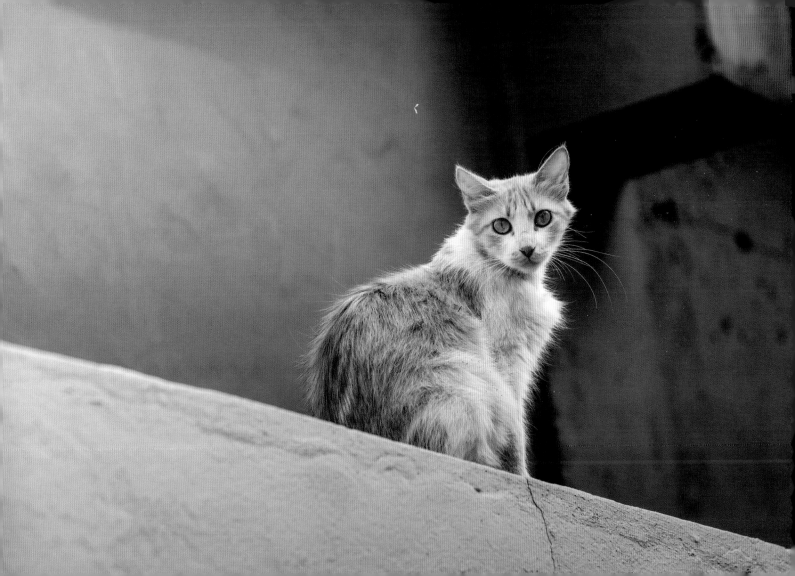

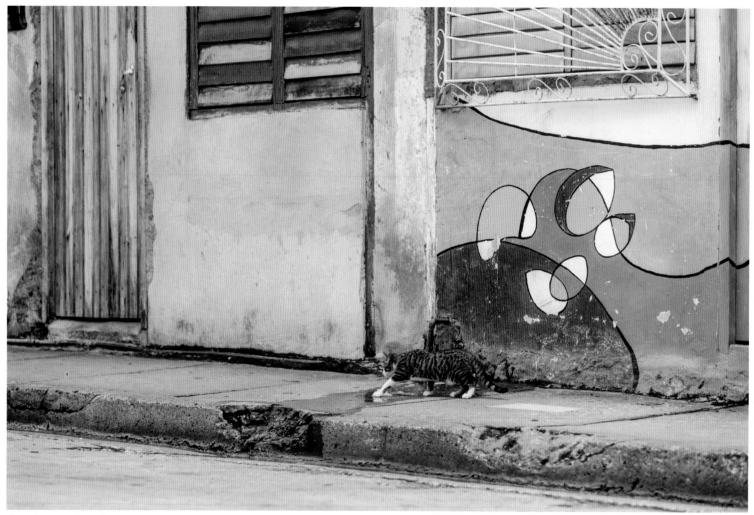

Guantánamo, Guantánamo

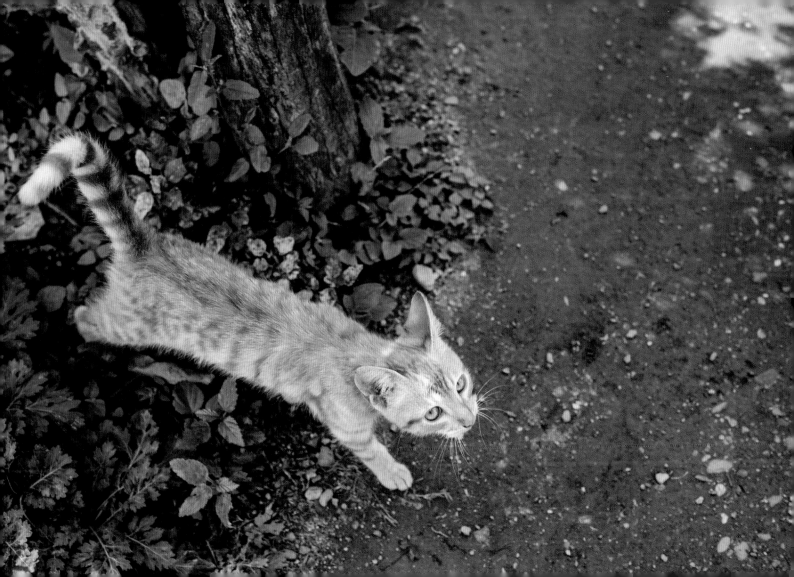

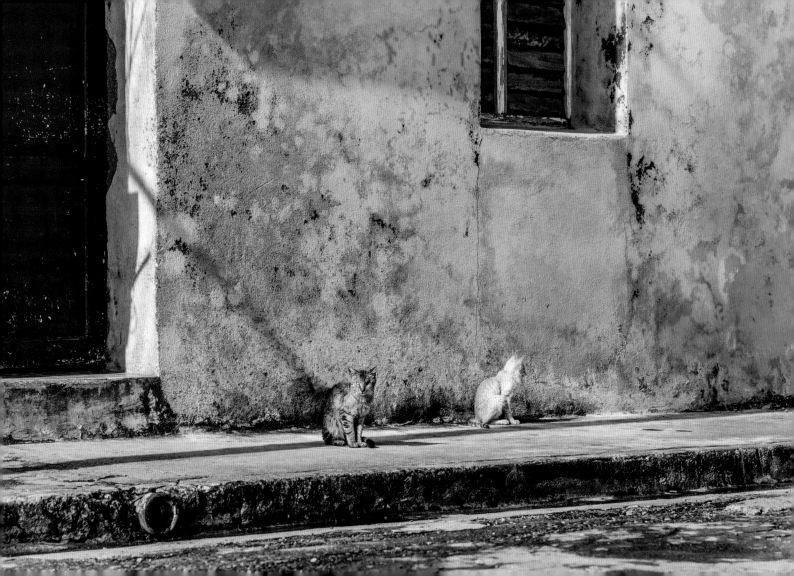

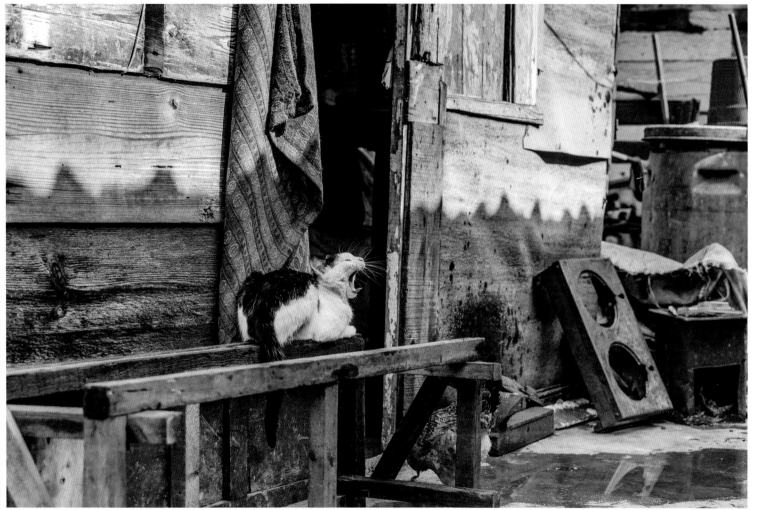

Baracoa, Granma

Tomás, Baracoa, Granma

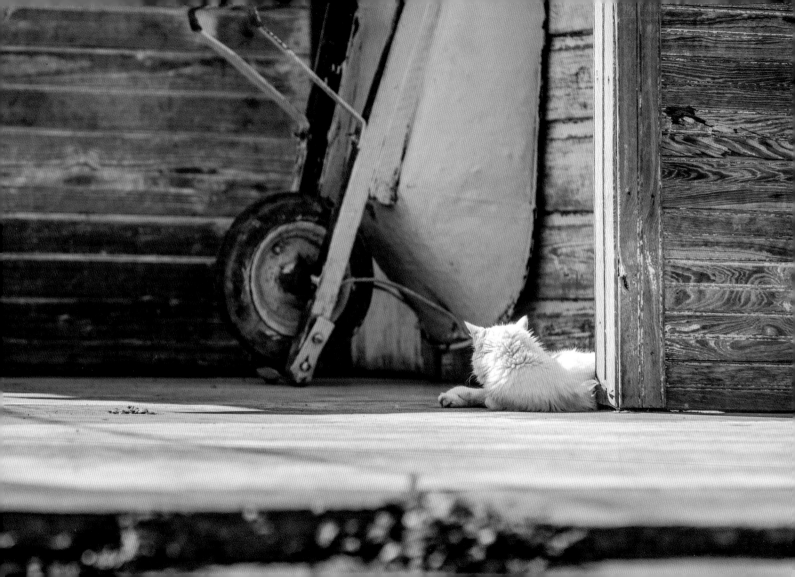

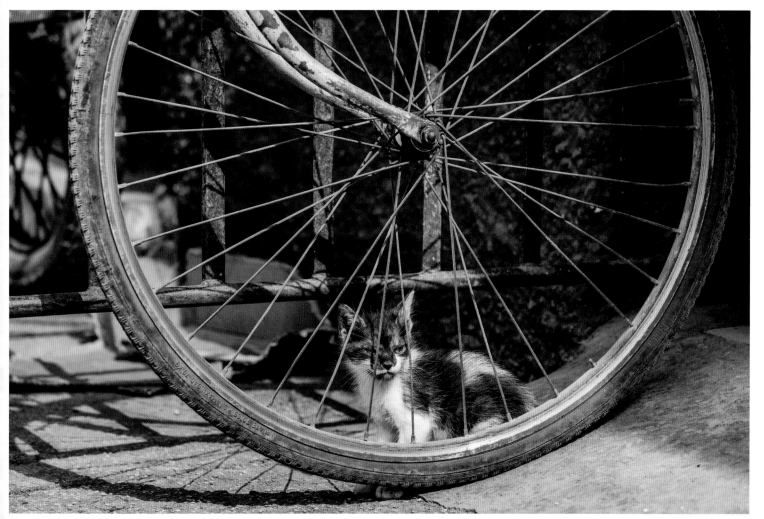

Bayamo, Granma

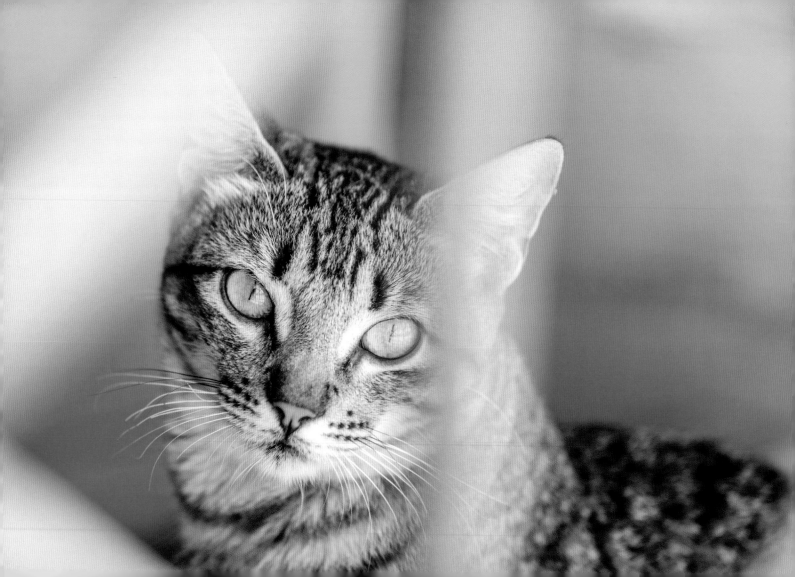

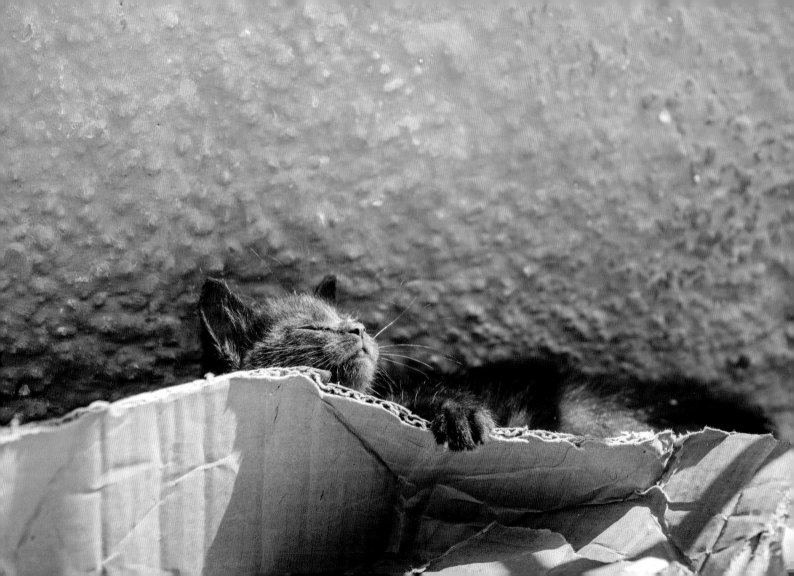

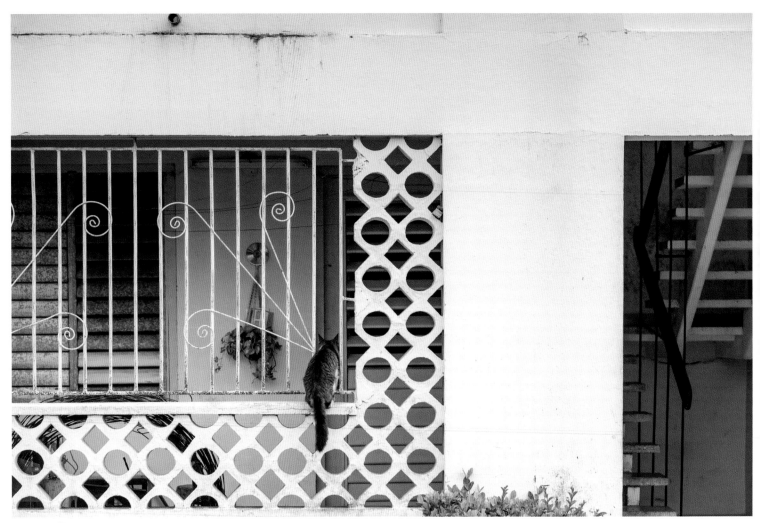

Bayamo, Granma

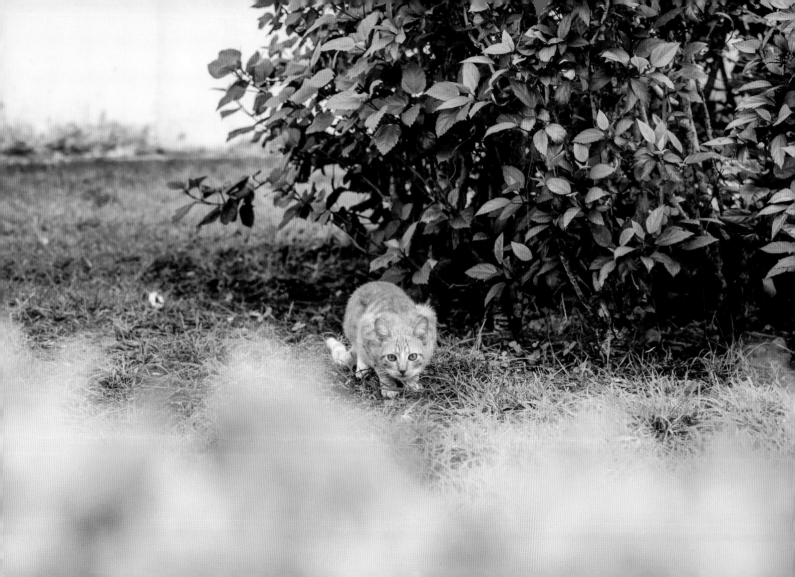

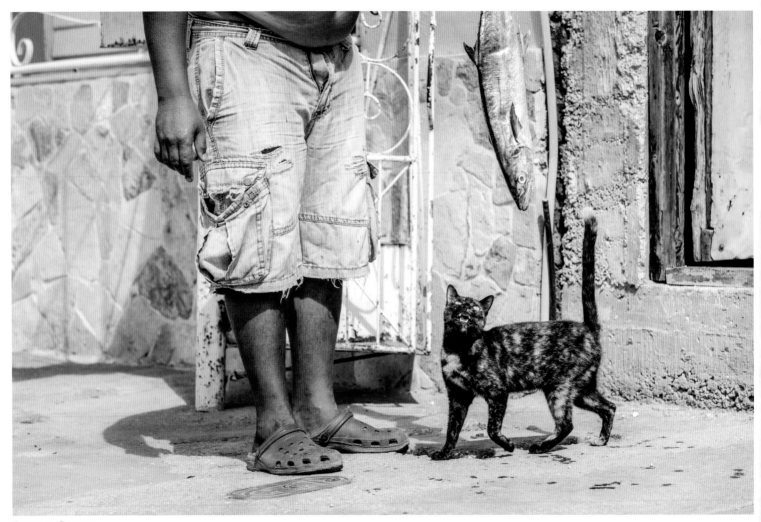

Bayamo, Granma

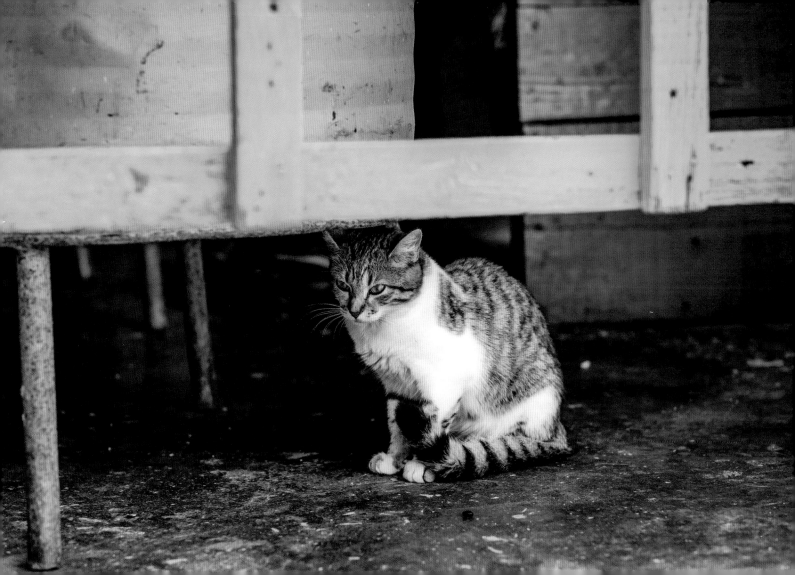

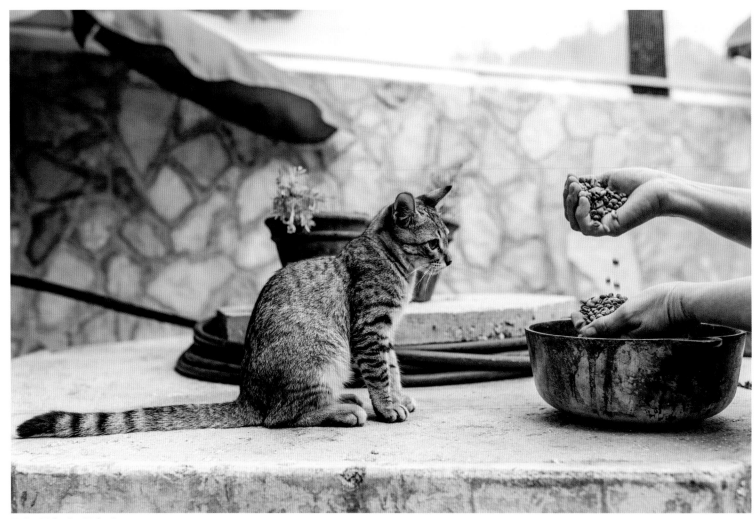

Peky, Holguín, Holguín

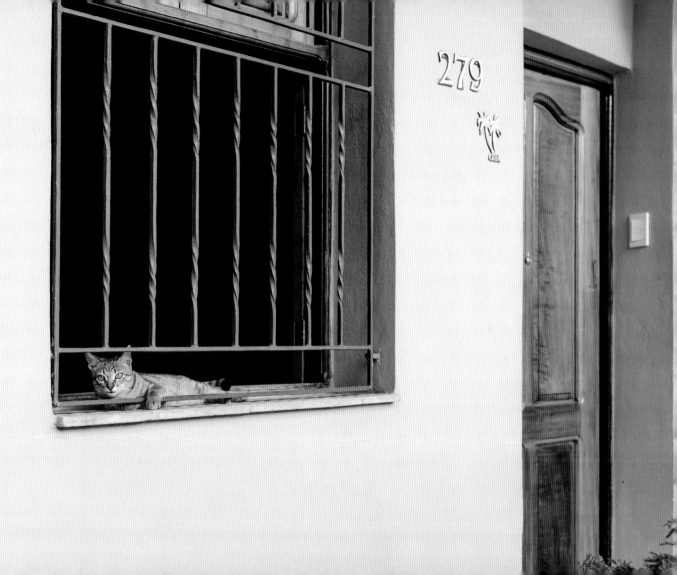

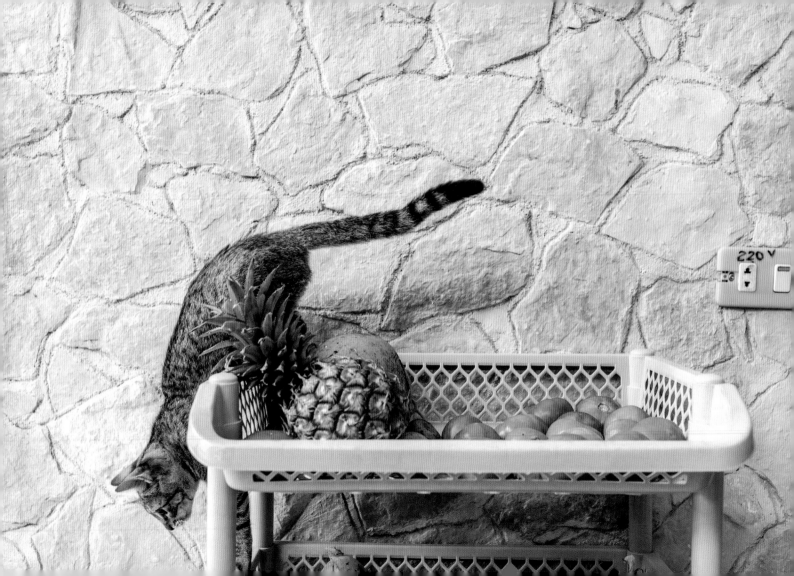

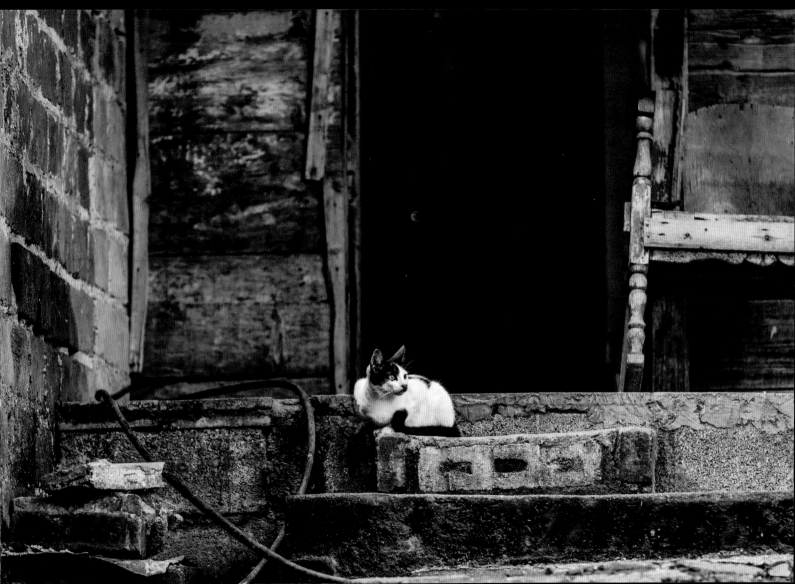

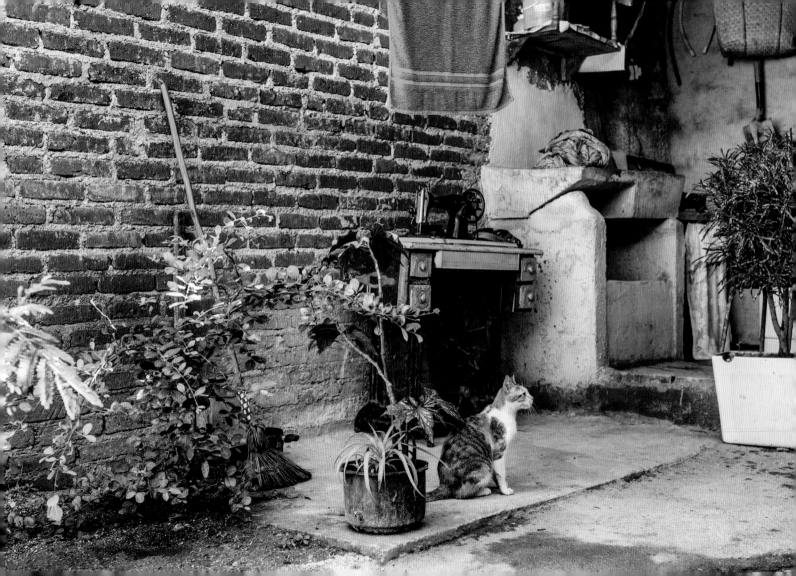

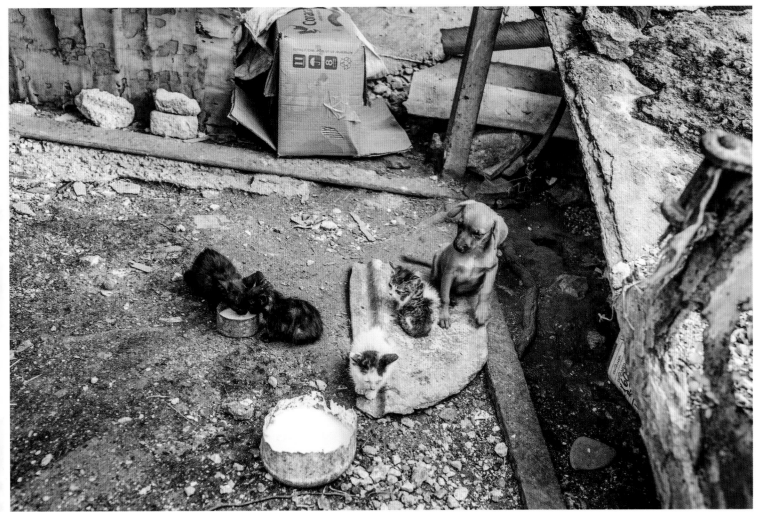

Holguín, Holguín

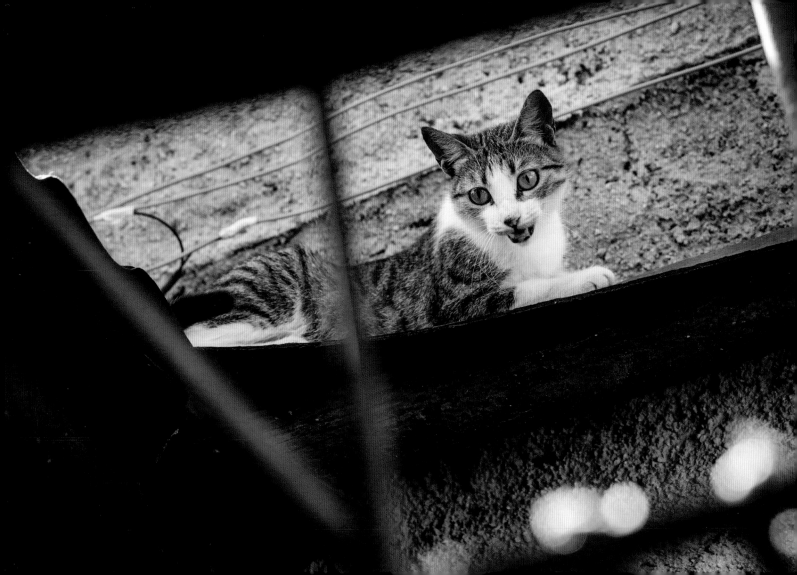

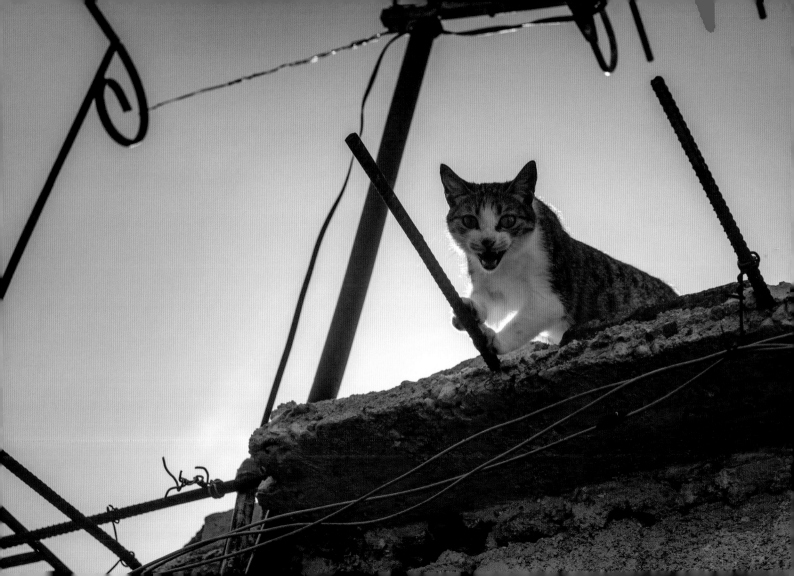

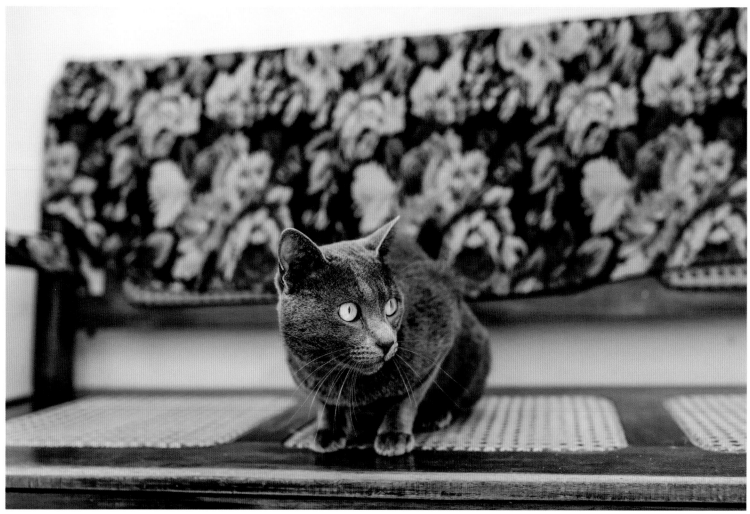

Banes, Holguín

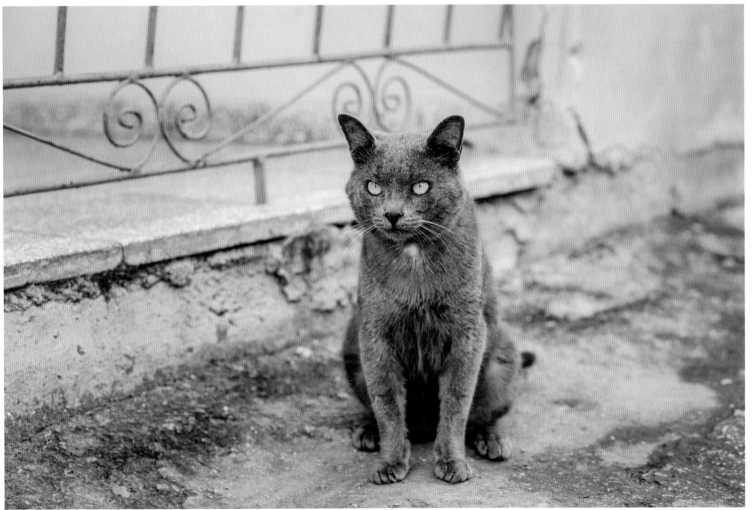

Holguín, Holguín

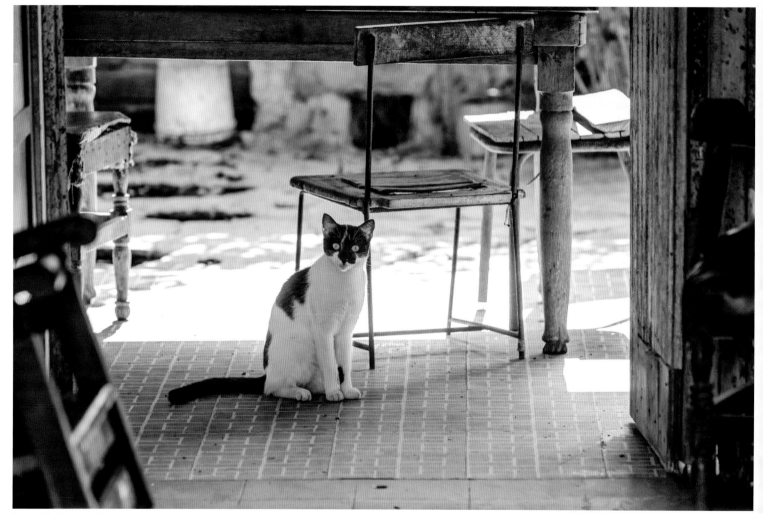

Puerto Padre, Las Tunas

Las Tunas, Las Tunas

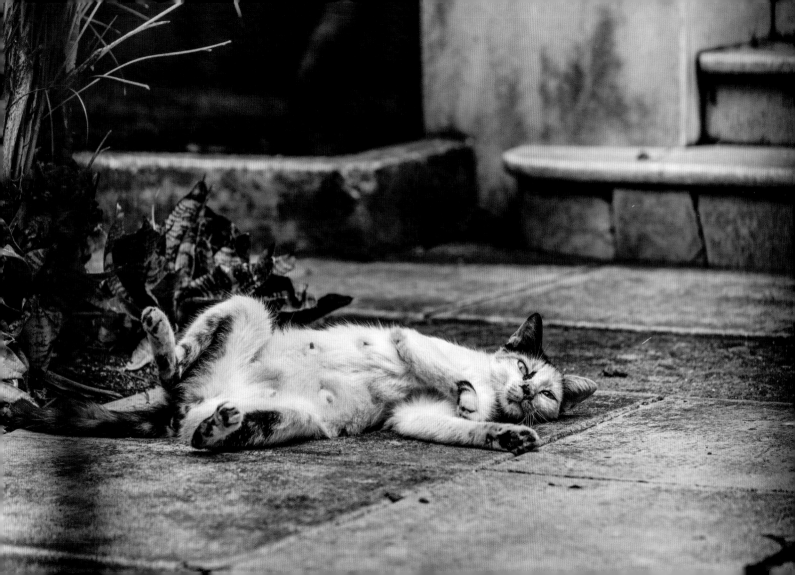

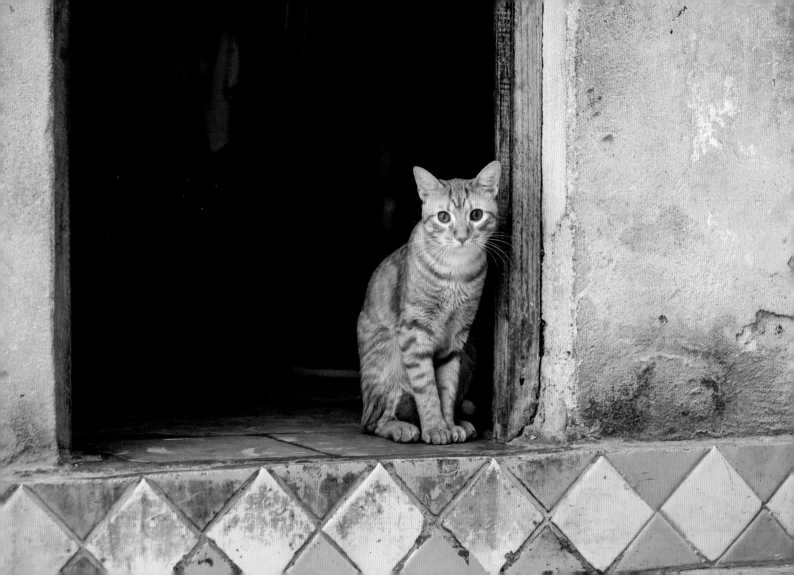

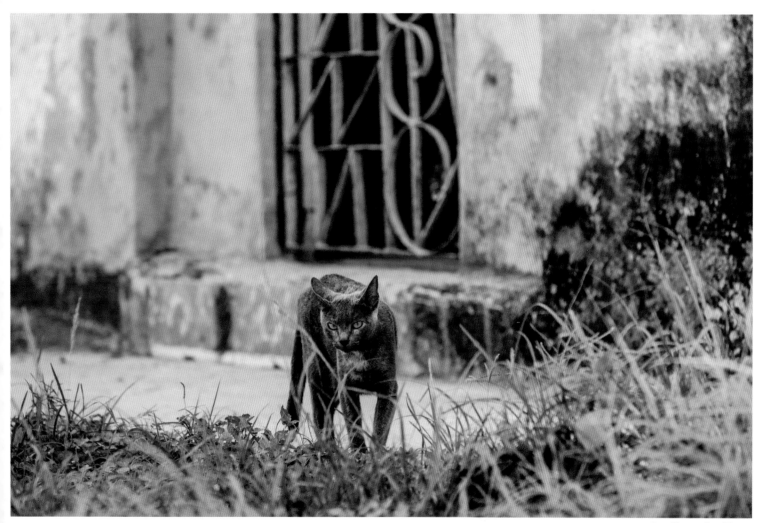

Las Tunas, Las Tunas

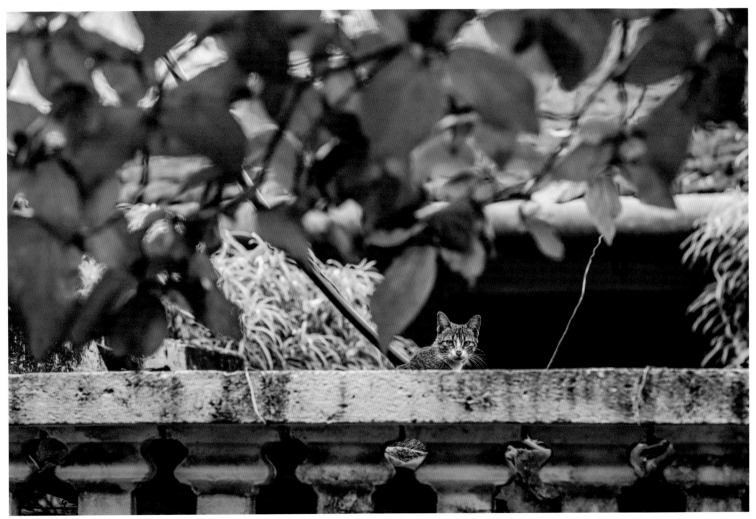

Puerto Padre, Las Tunas

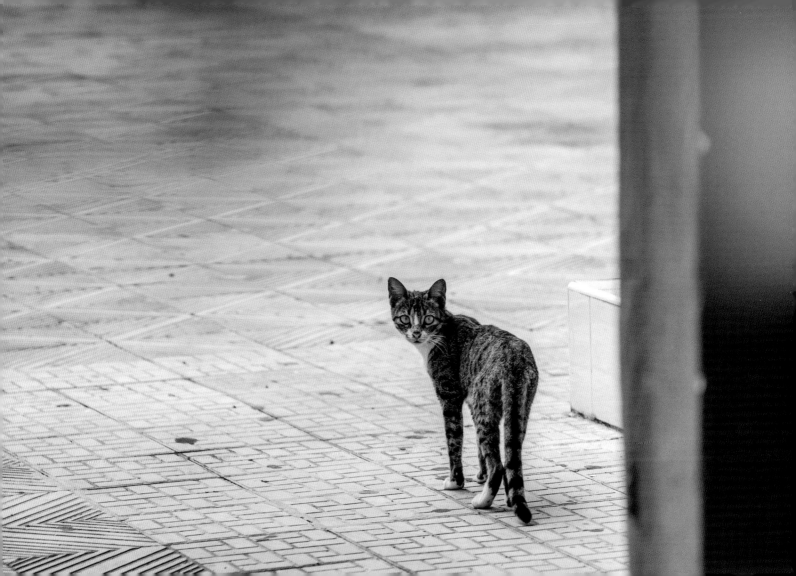

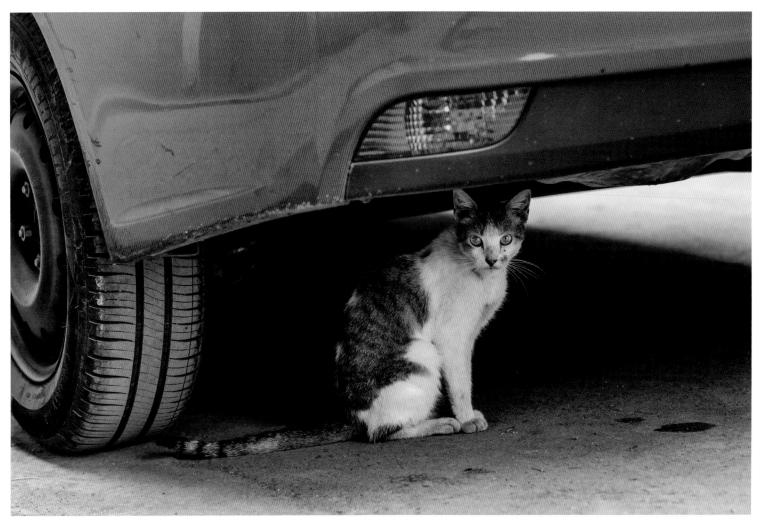

Puerto Padre, Las Tunas

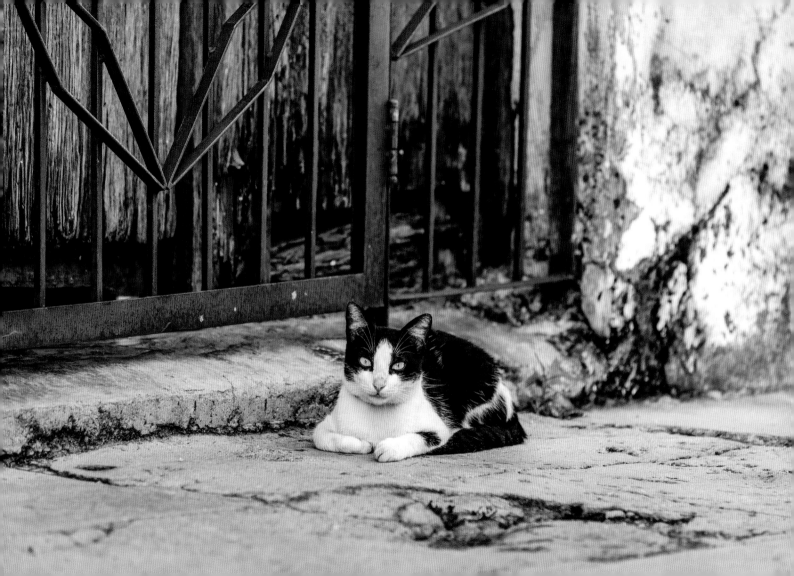

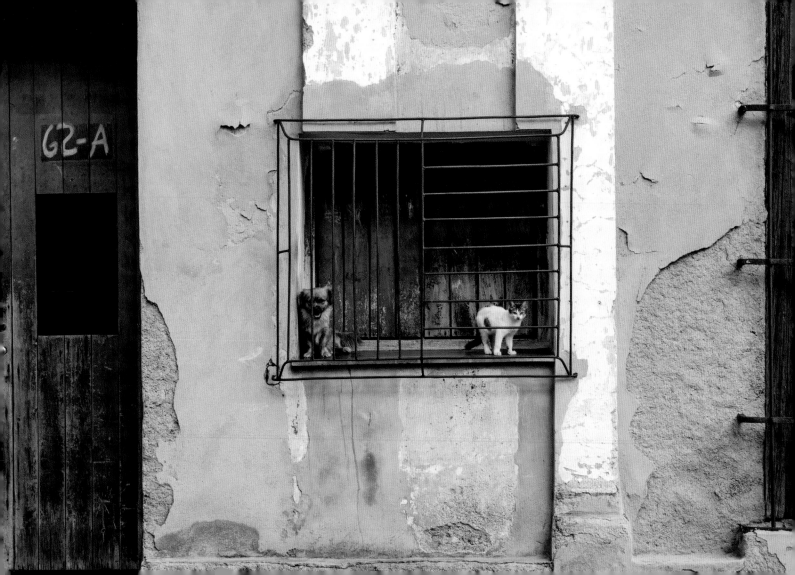

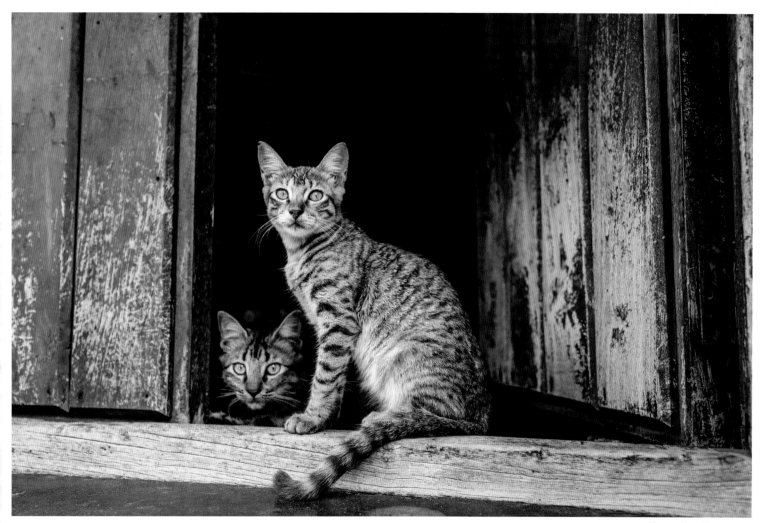

Camagüey, Camagüey

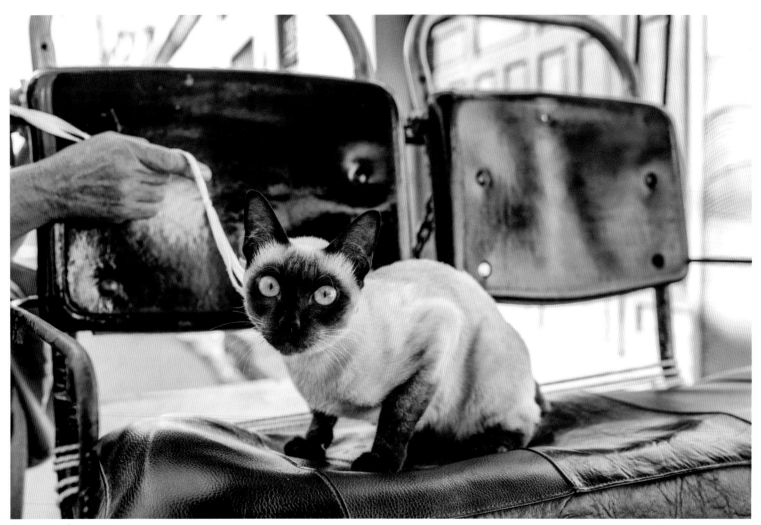

Camagüey, Camagüey

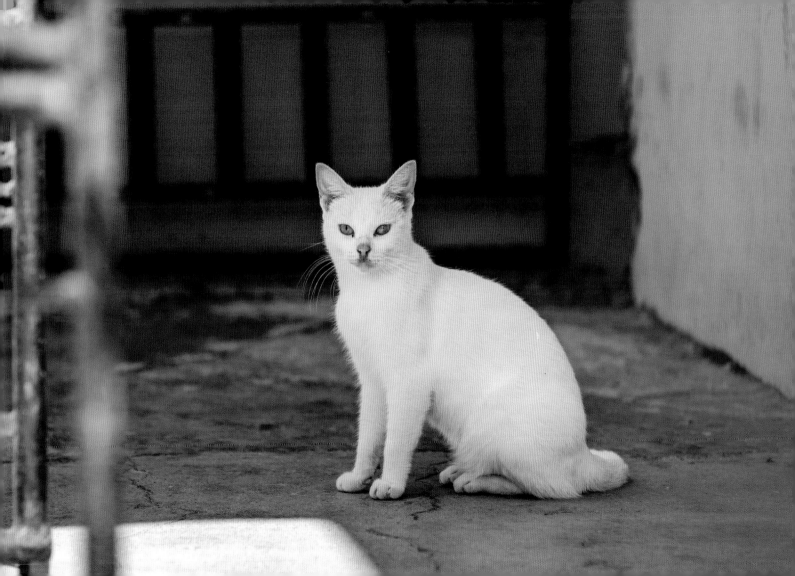

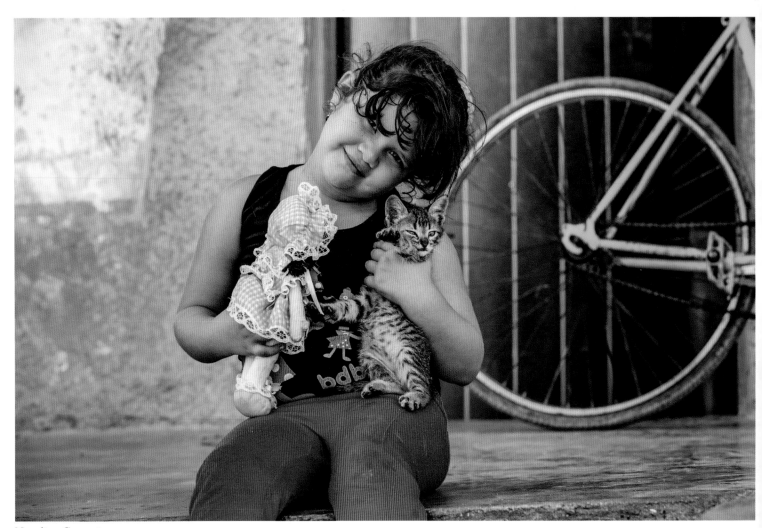

Nuevitas, Camagüey

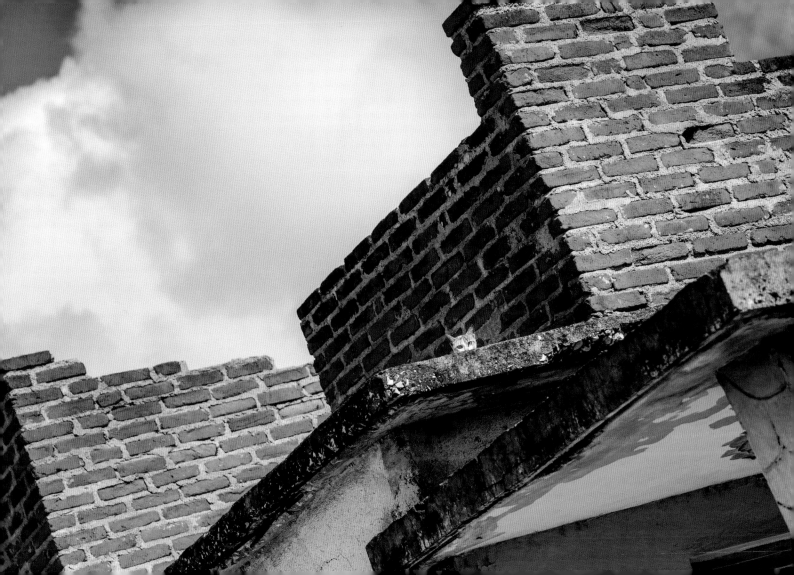

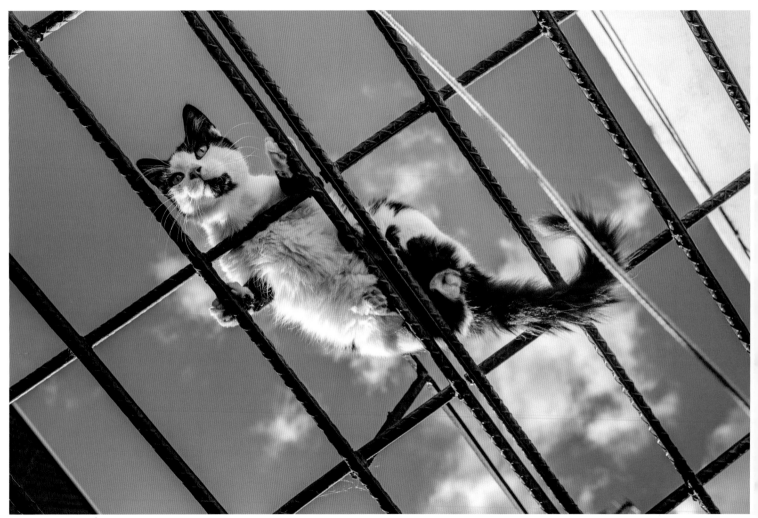

Morón, Ciego de Ávila

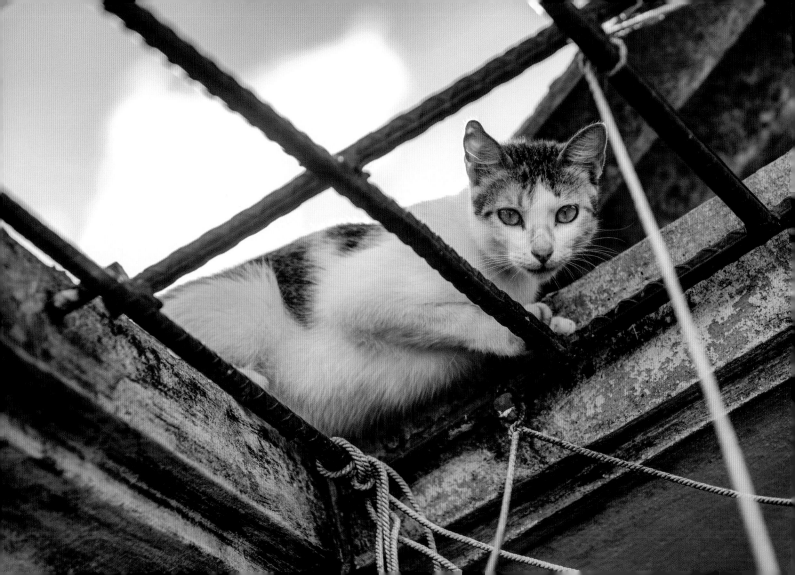

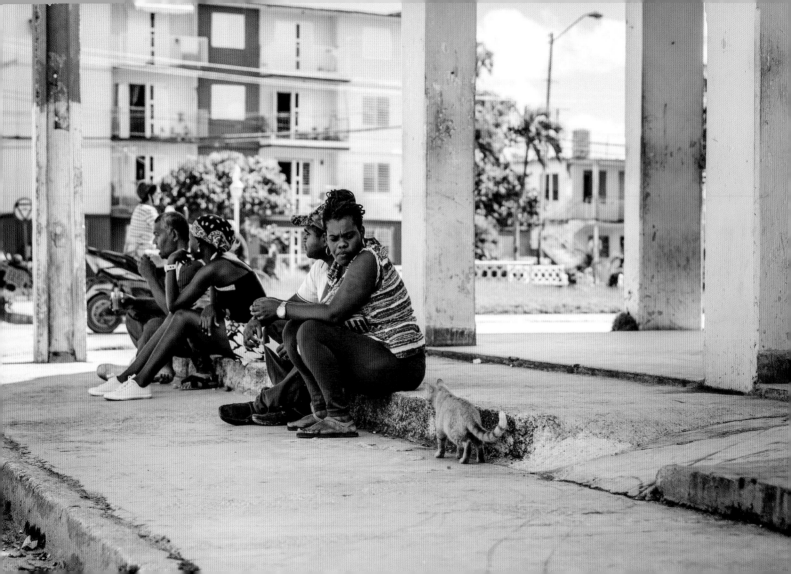

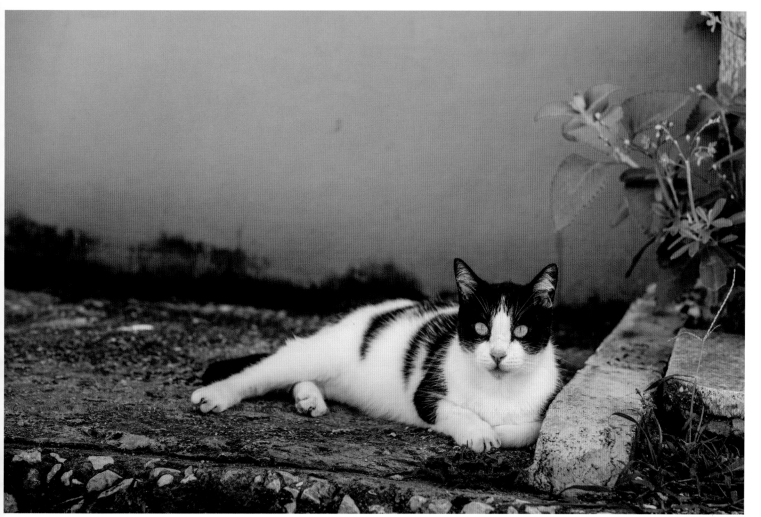

Morón, Ciego de Ávila

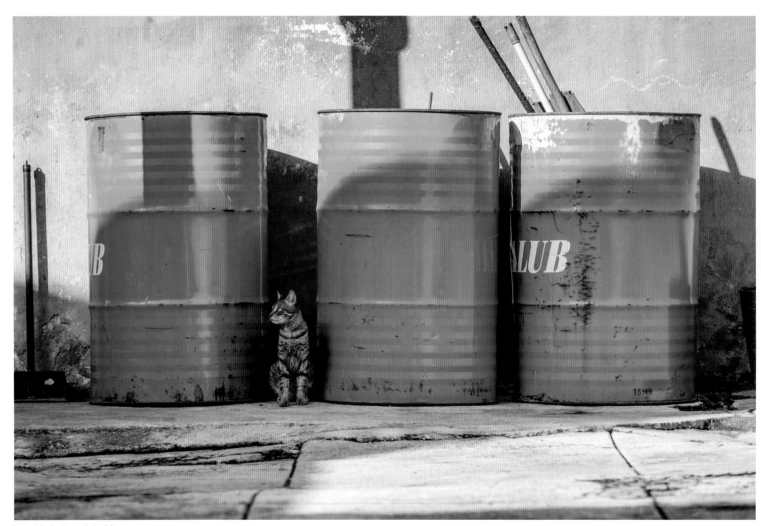

Trinidad, Sancti Spíritus

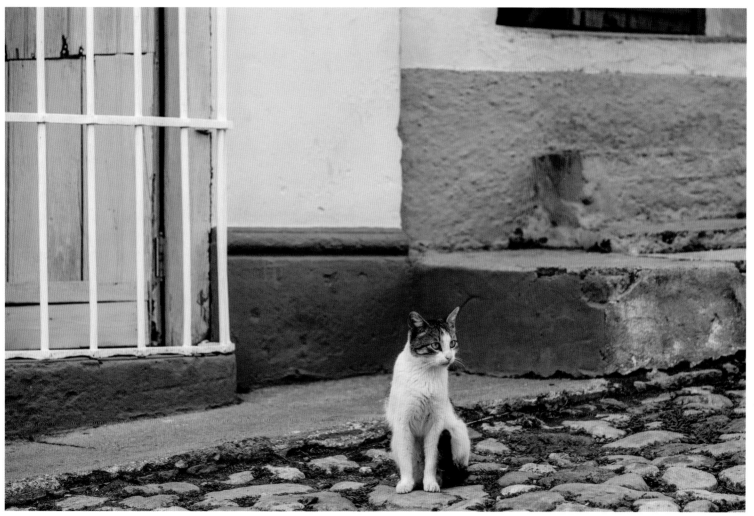

Trinidad, Sancti Spíritus

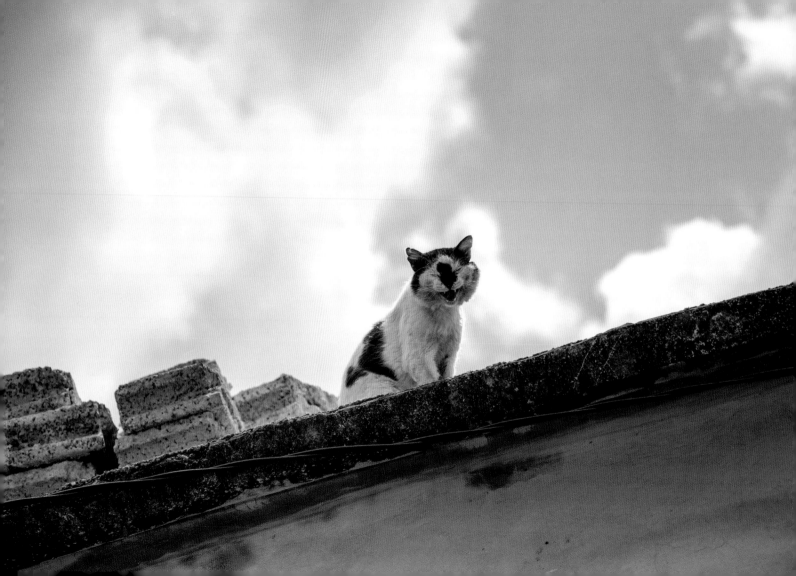

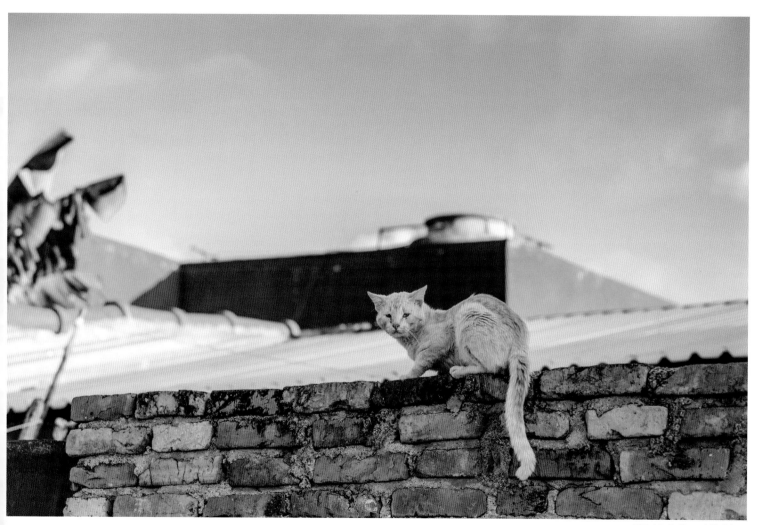

Trinidad, Sancti Spíritus

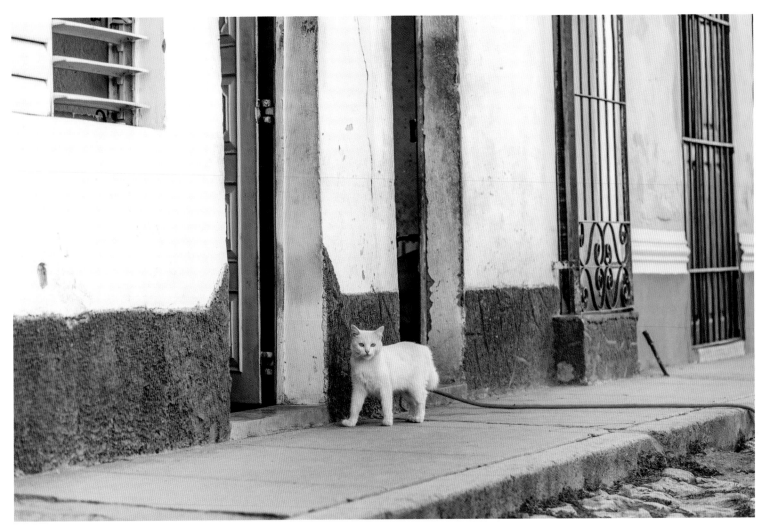

Sancti Spíritus, Sancti Spíritus

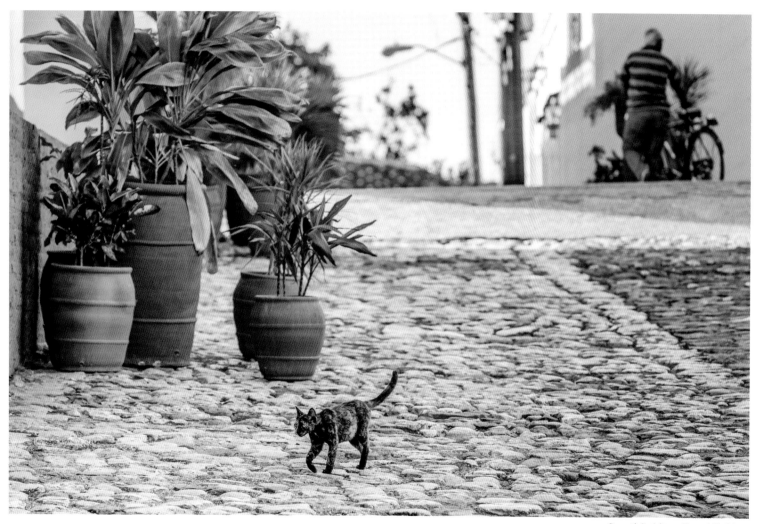

Sancti Spíritus, Sancti Spíritus

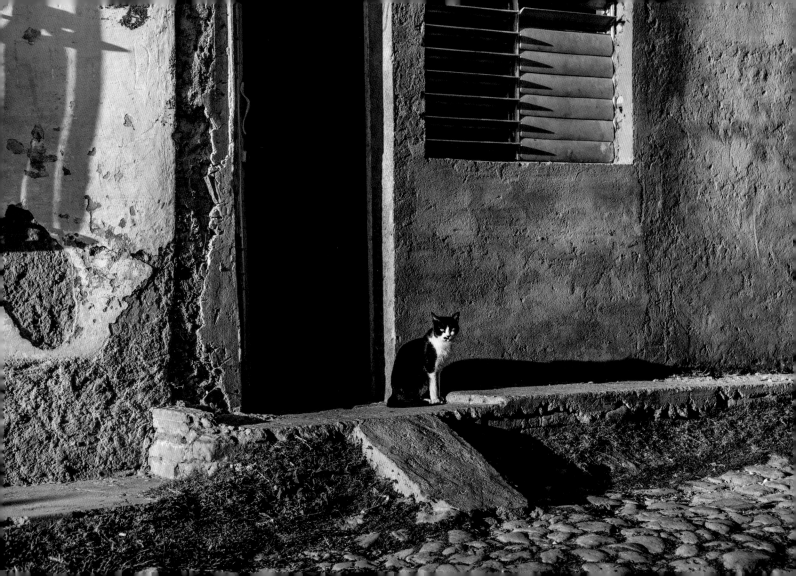

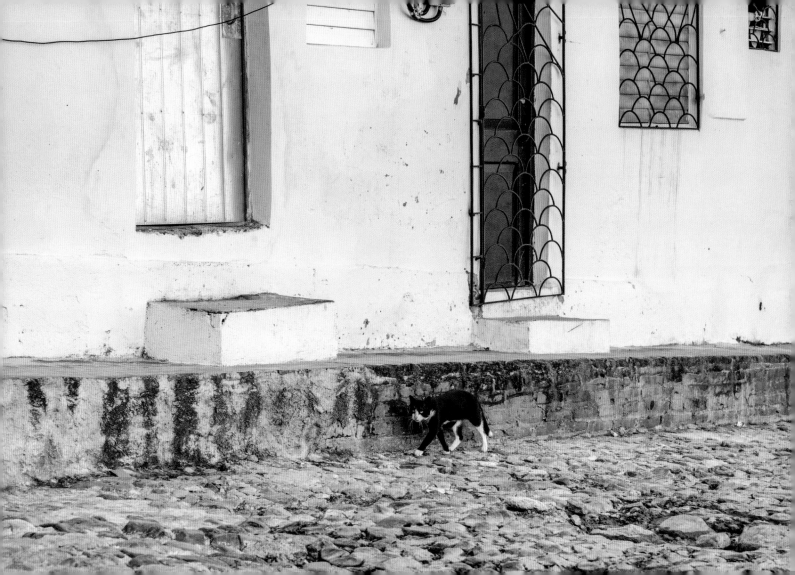

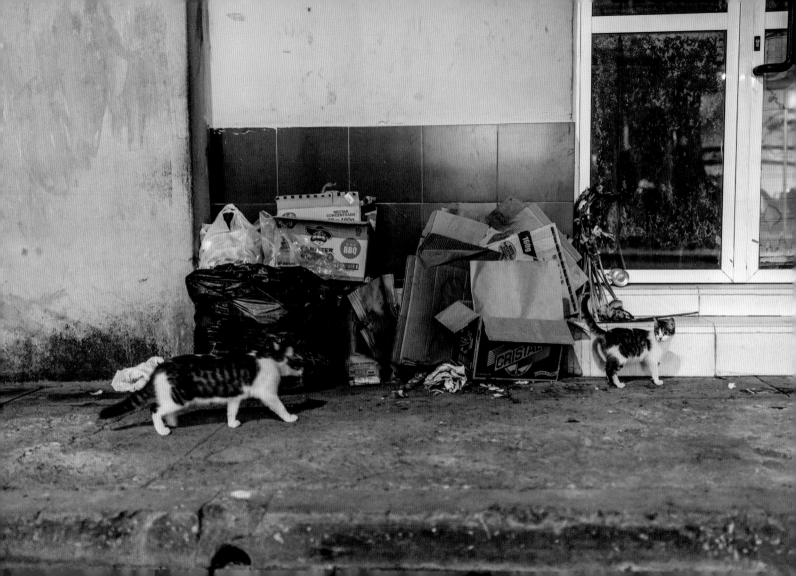

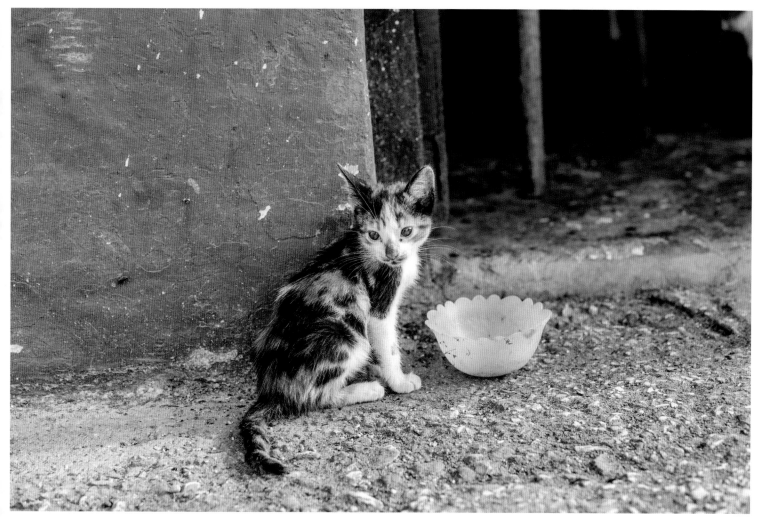

Cienfuegos, Cienfuegos

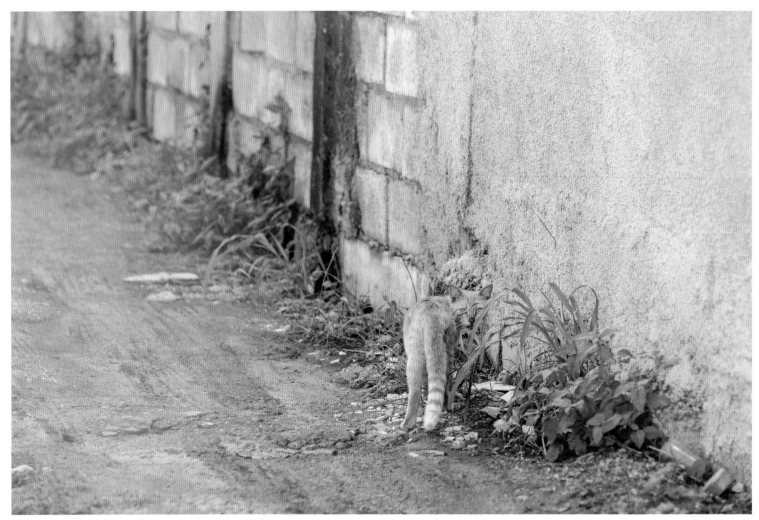

Cienfuegos, Cienfuegos

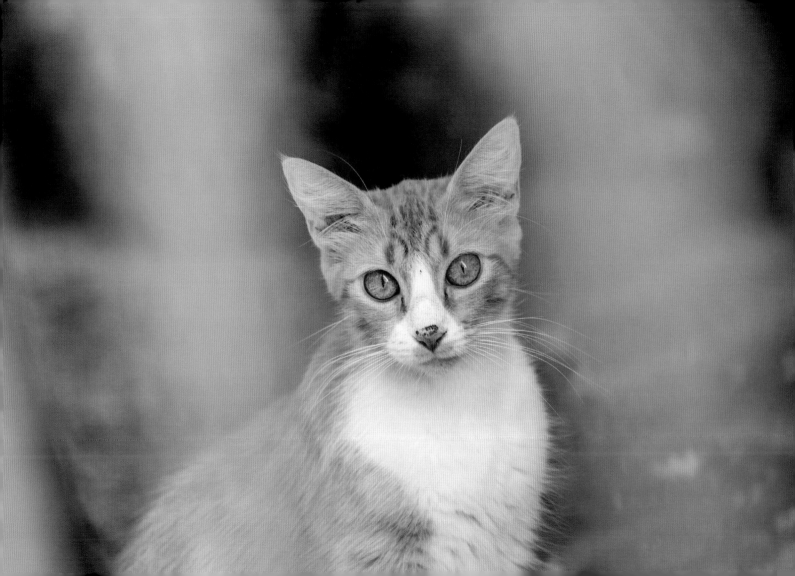

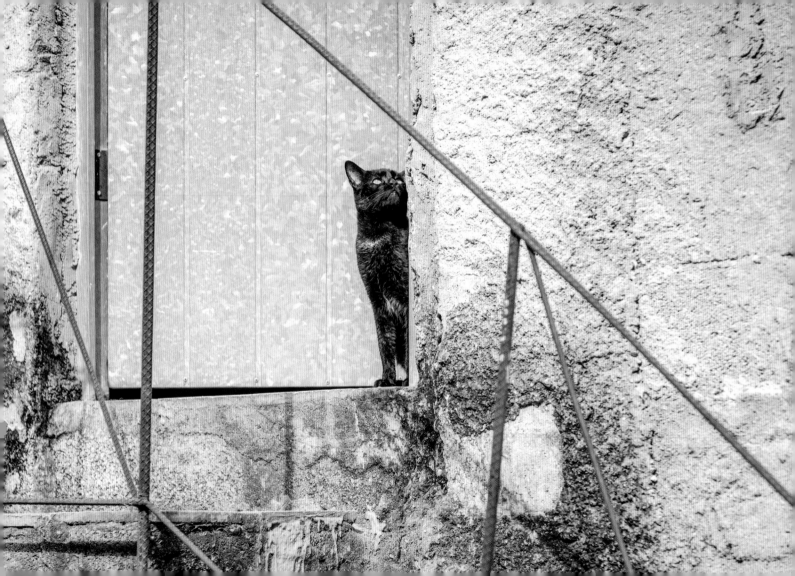

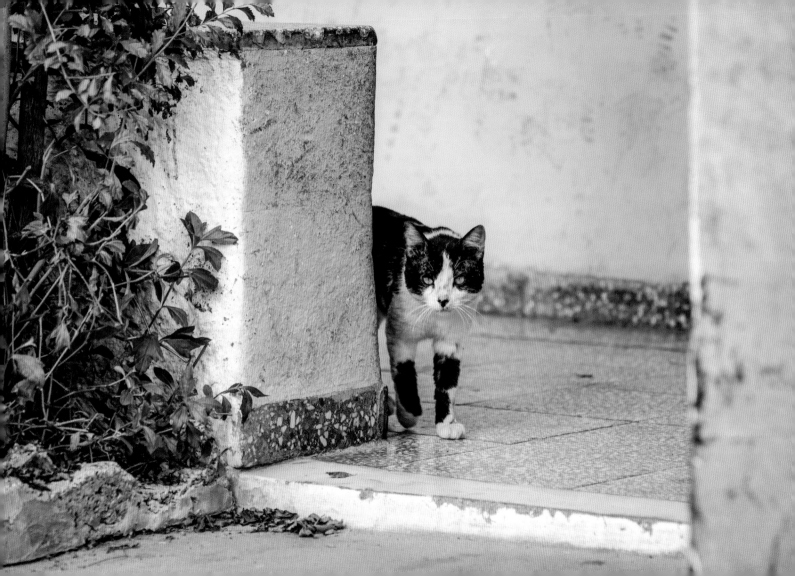

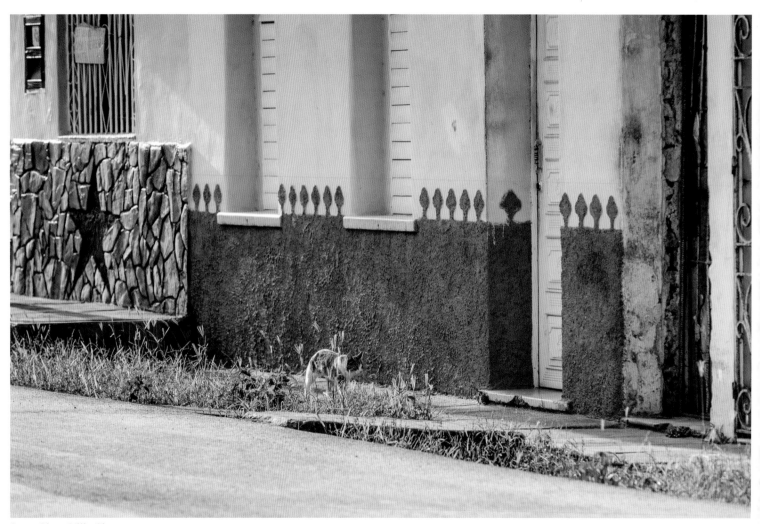

Santa Clara, Villa Clara

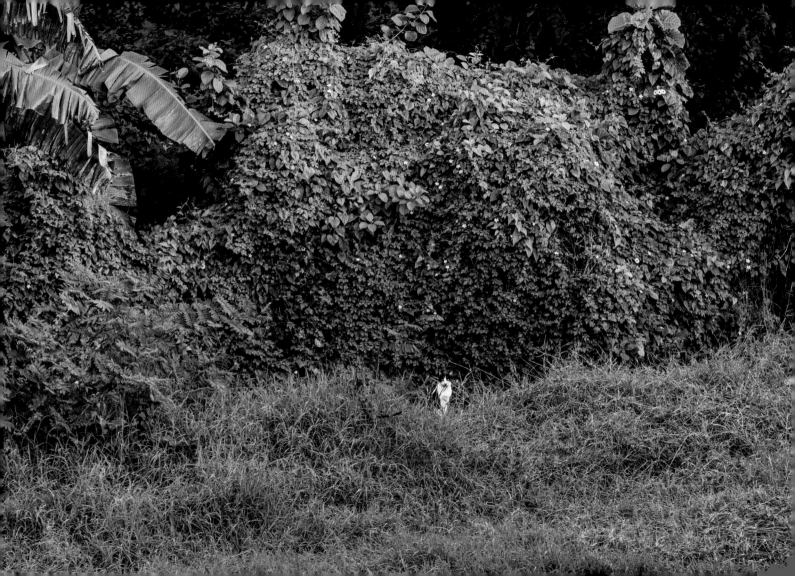

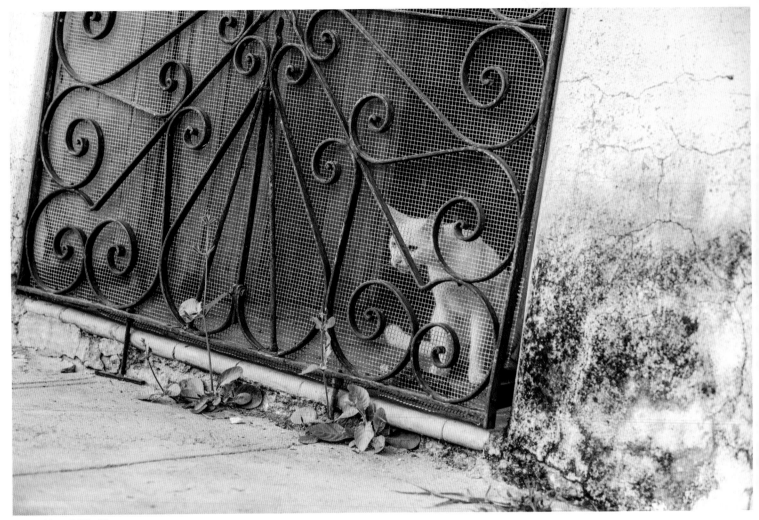

Santa Clara, Villa Clara

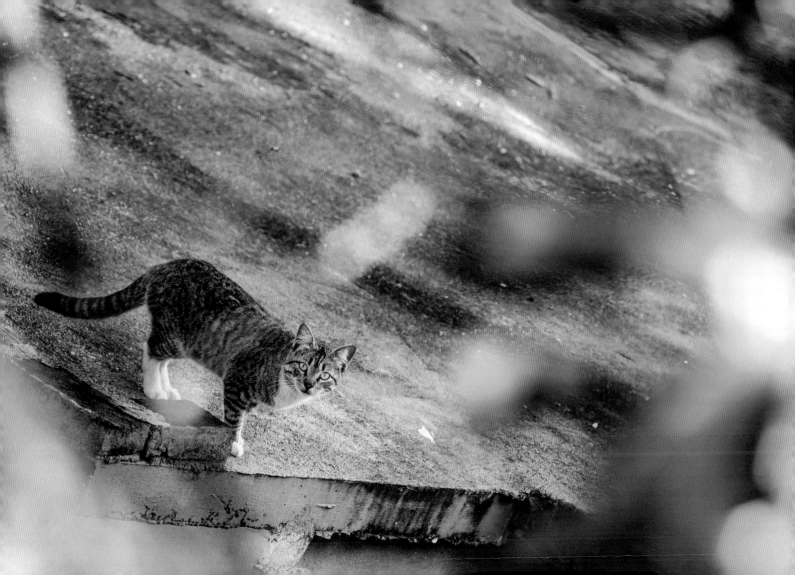

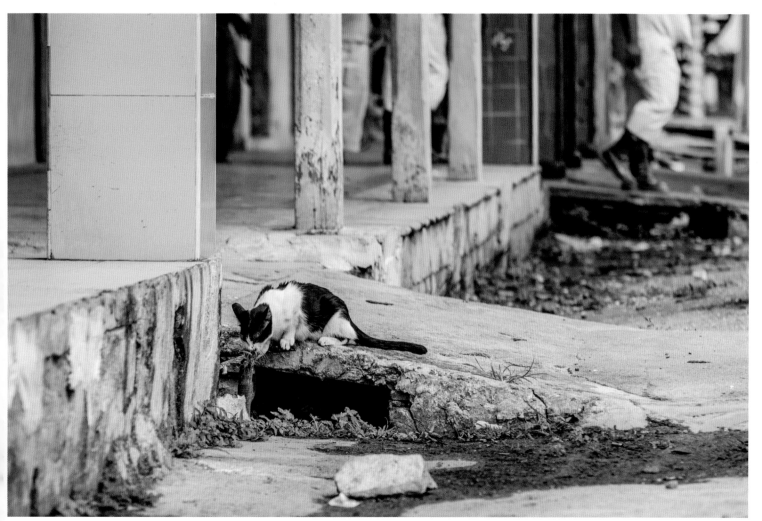

Caibarién, Villa Clara

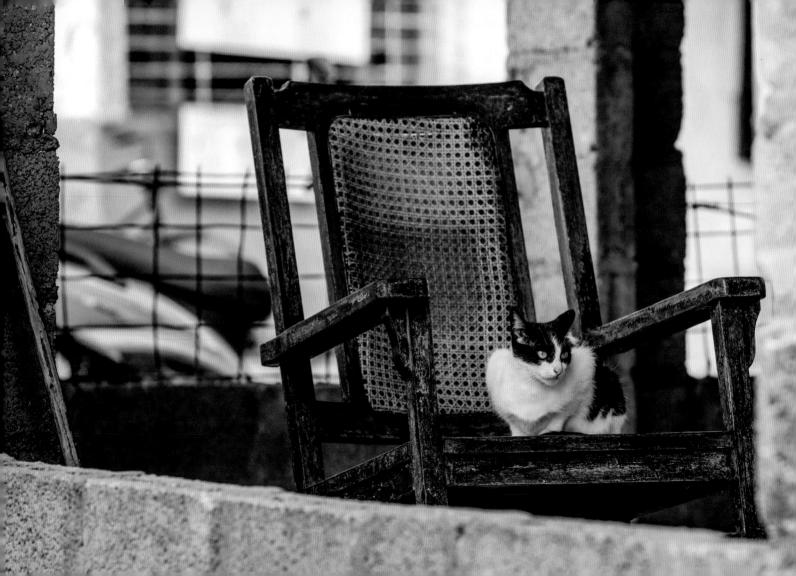

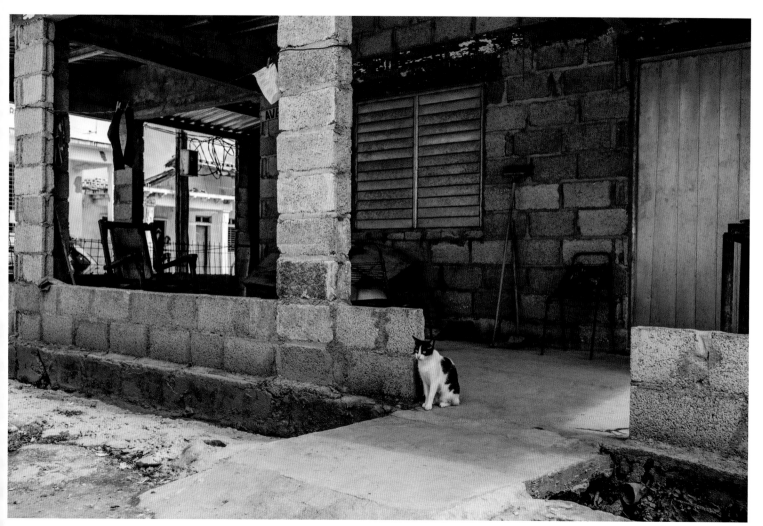

Caibarién, Villa Clara

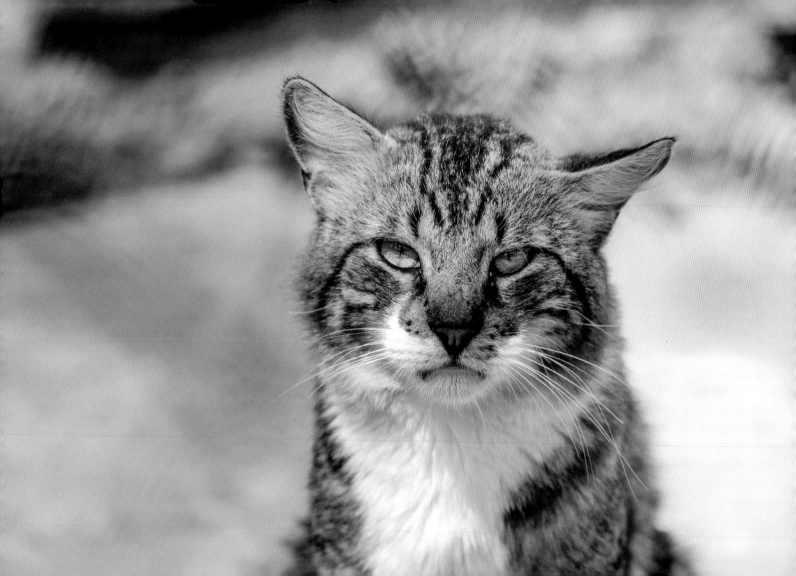

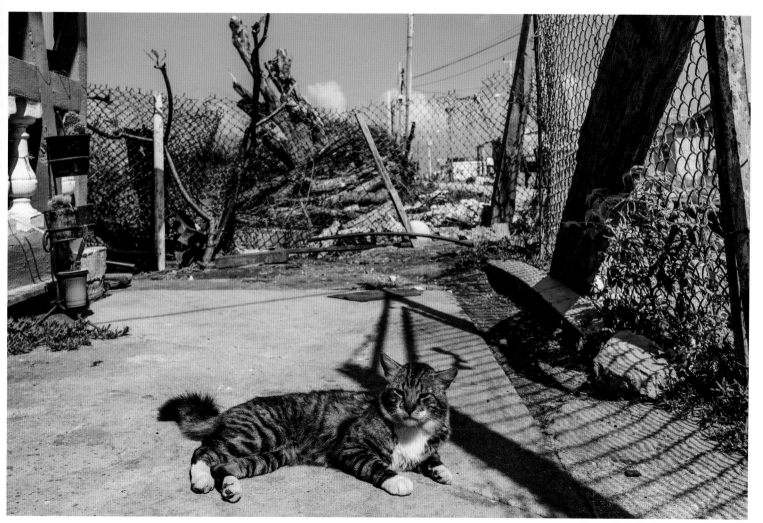

Guapo, Isabela de Sagua, Villa Clara

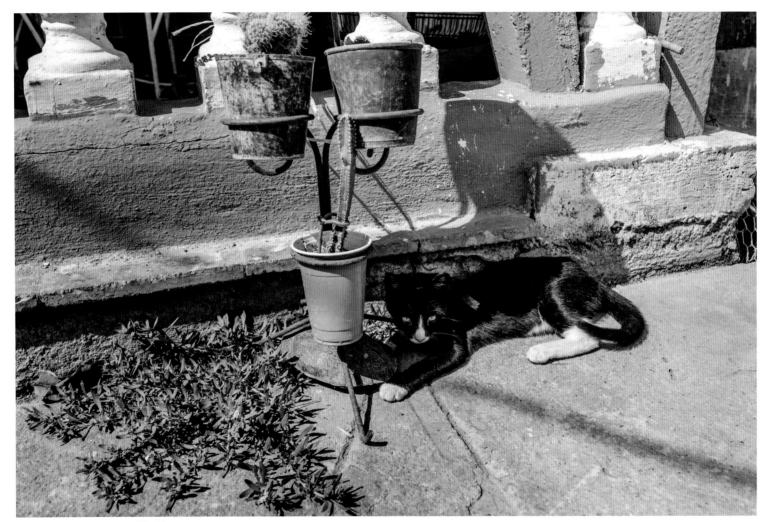

Duke, Isabela de Sagua, Villa Clara

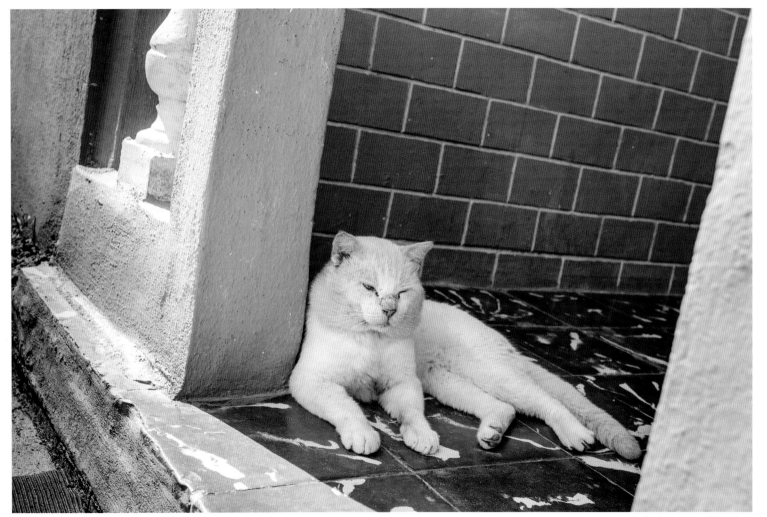

Macho, Isabela de Sagua, Villa Clara

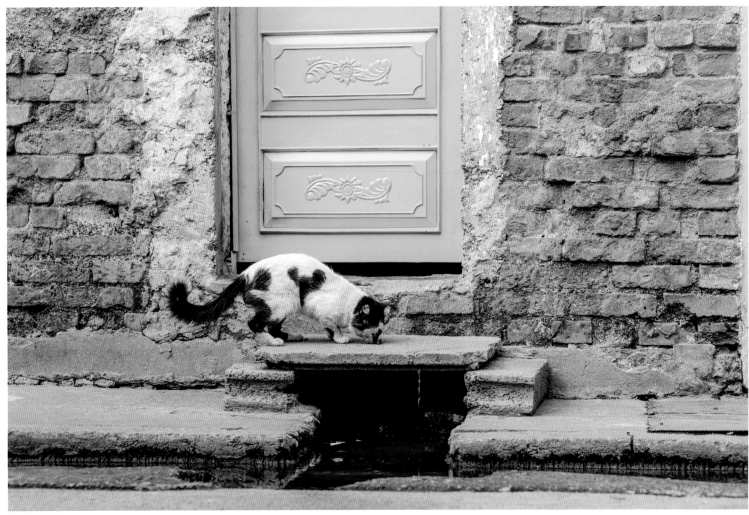

Versalles, Matanzas, Matanzas

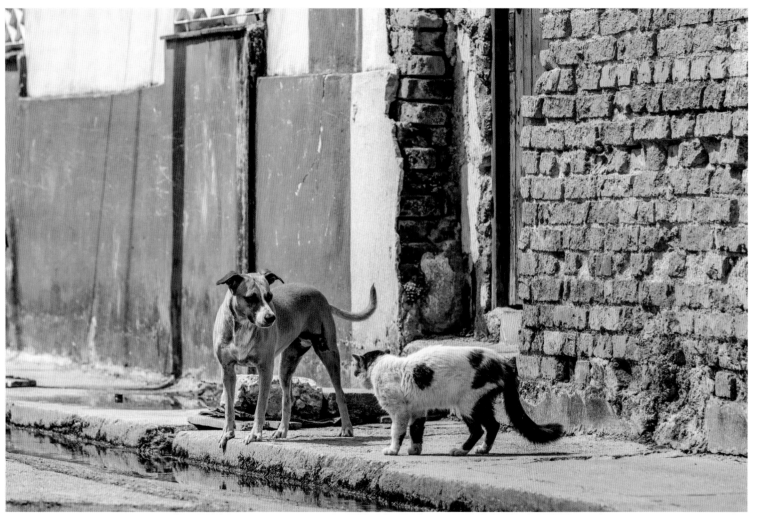

Versalles, Matanzas, Matanzas

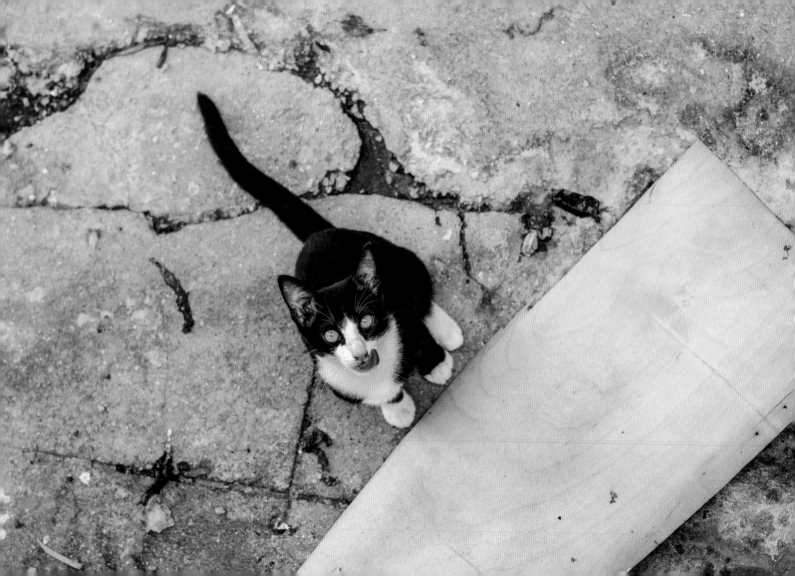

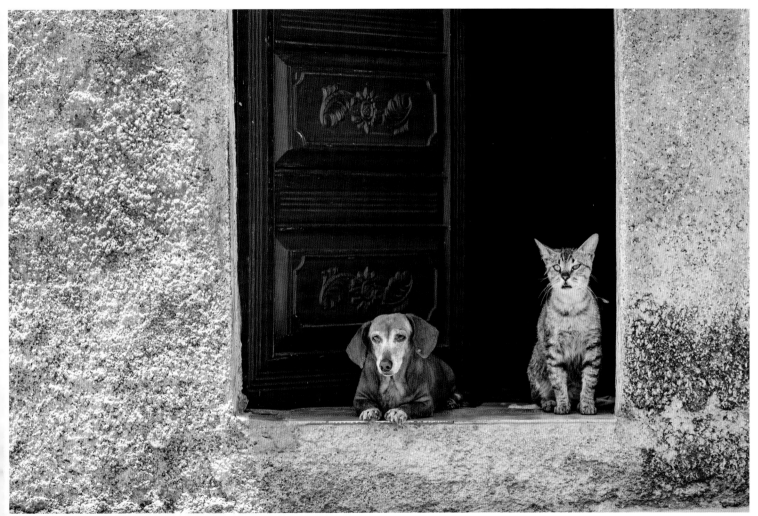

Versalles, Matanzas, Matanzas

Betty y Sebastian, Versalles, Matanzas, Matanzas

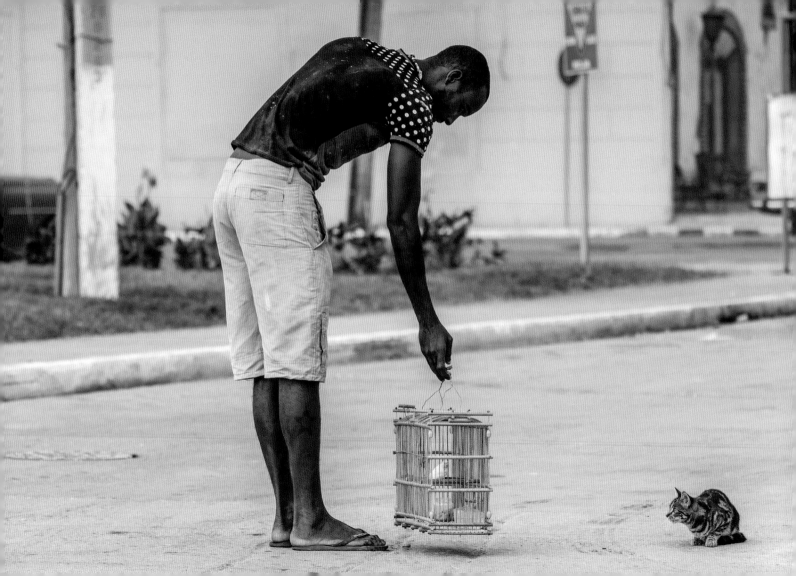

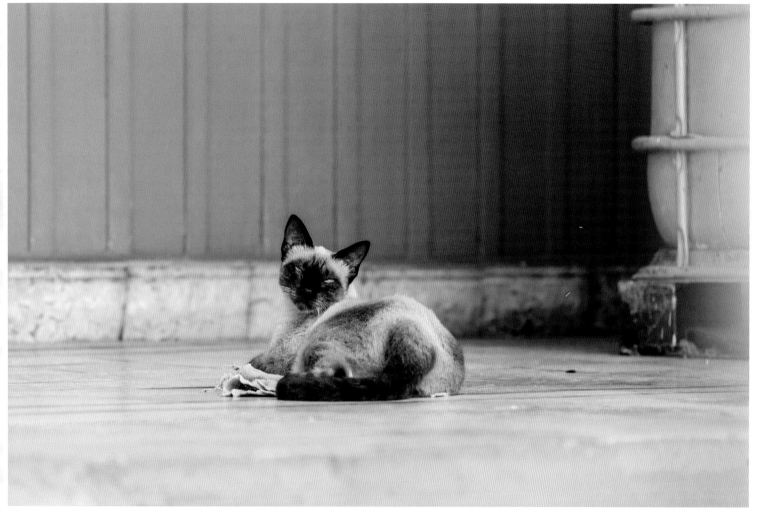

Matanzas, Matanzas

Pueblo Nuevo, Matanzas, Matanzas

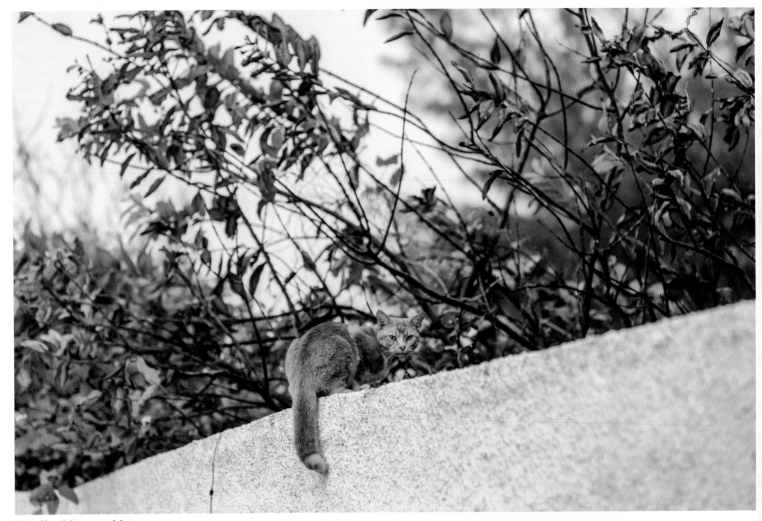

Versalles, Matanzas, Matanzas

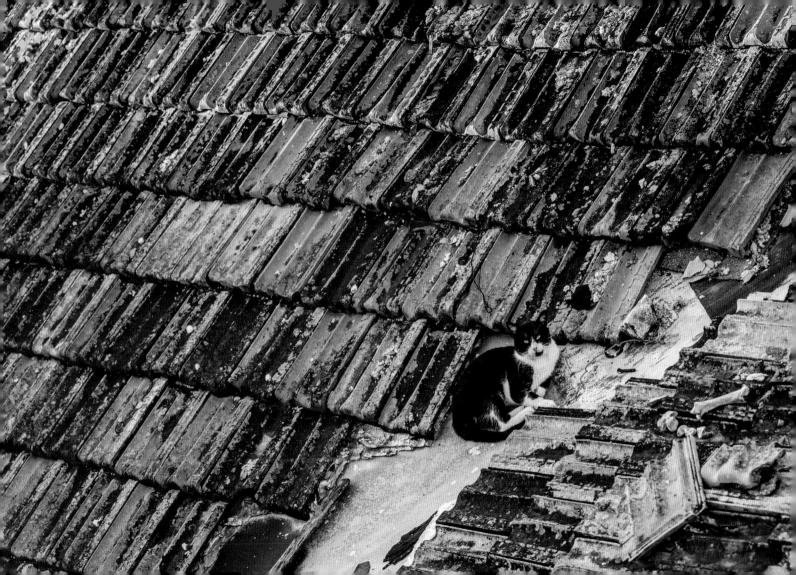

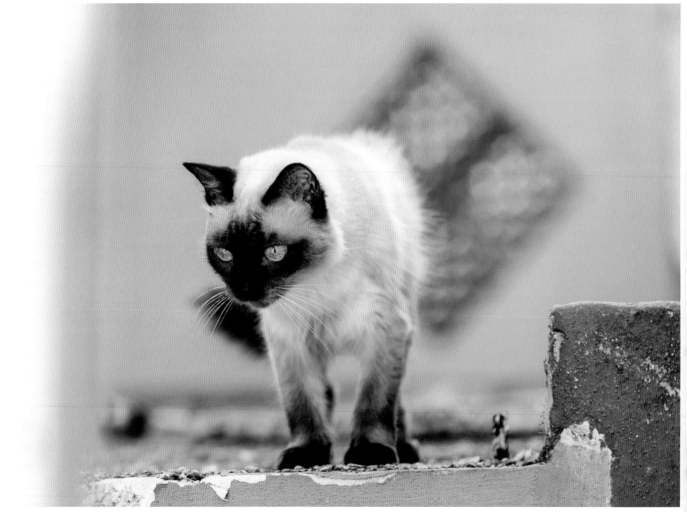

Versalles, Matanzas, Matanzas

Dulce, Cárdenas, Matanzas

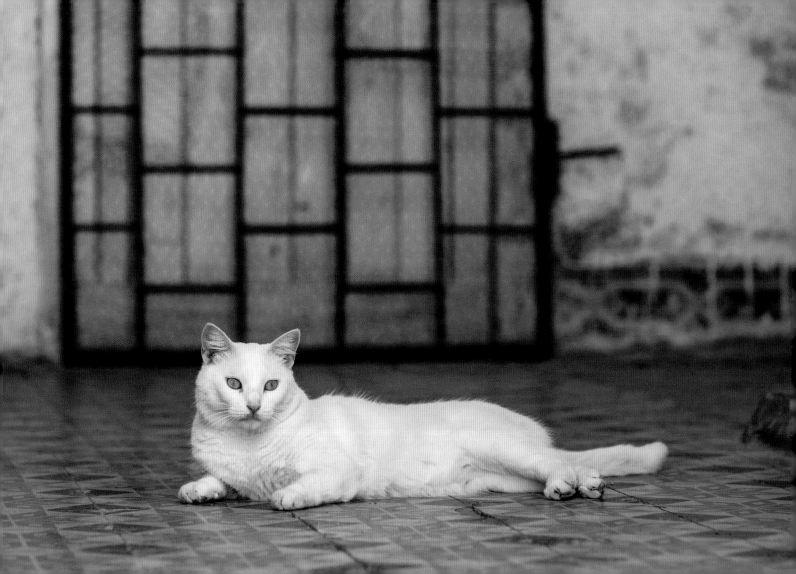

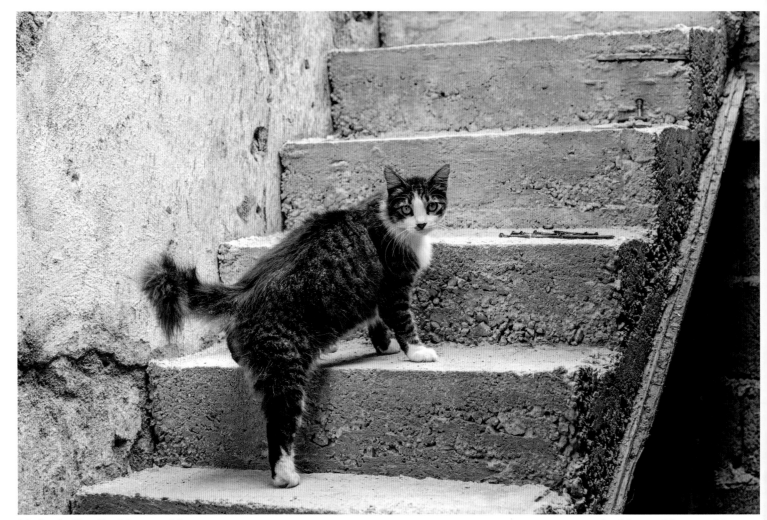

Minúscula, Versalles, Matanzas, Matanzas

Los Mangos, Matanzas, Matanzas

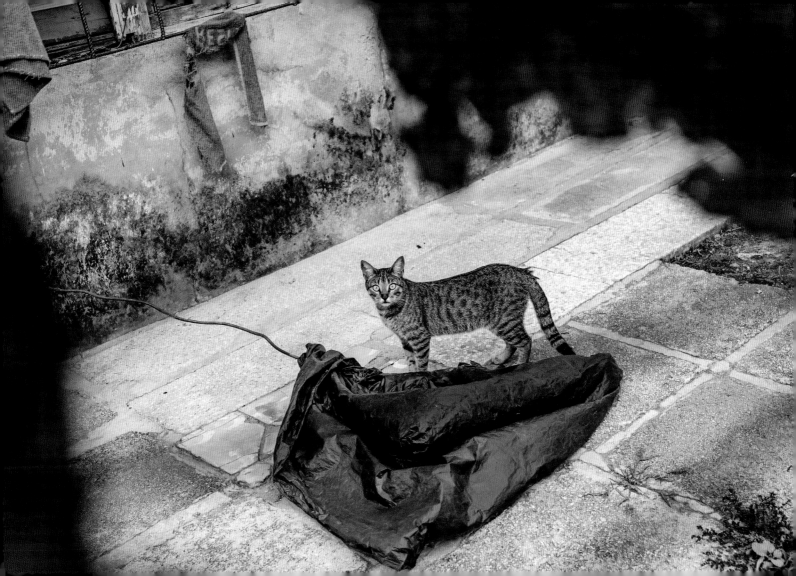

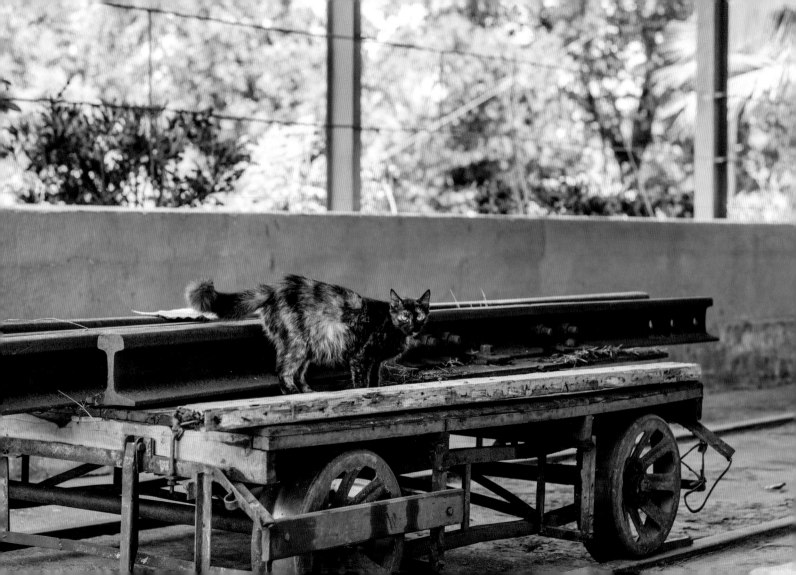

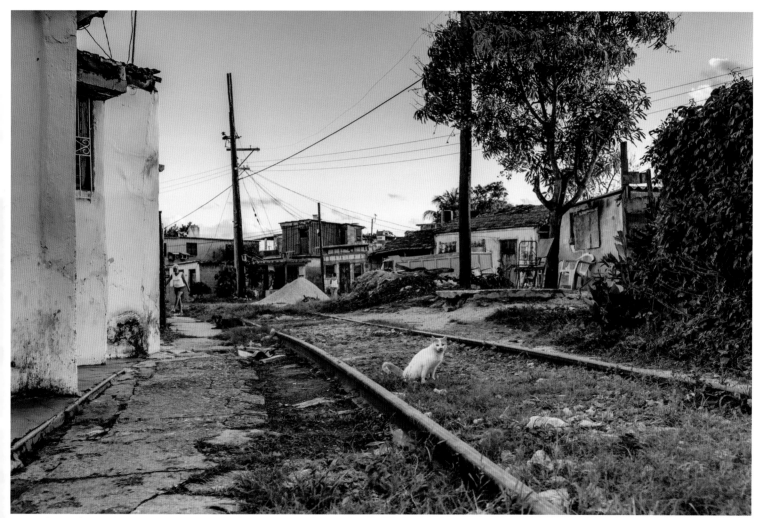

Lizzy, El Tren de Hershey, Matanzas, Matanzas

Versalles, Matanzas, Matanzas

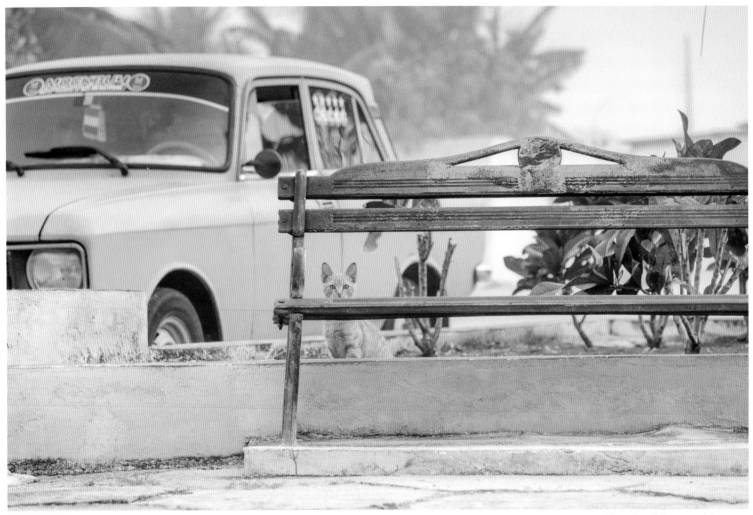

Ruvio, Parque El Chiquirrín, Versalles, Matanzas, Matanzas

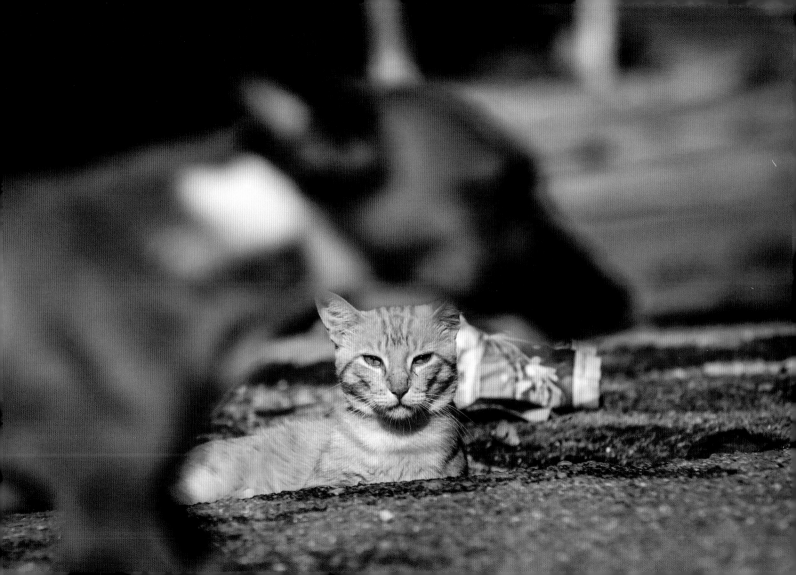

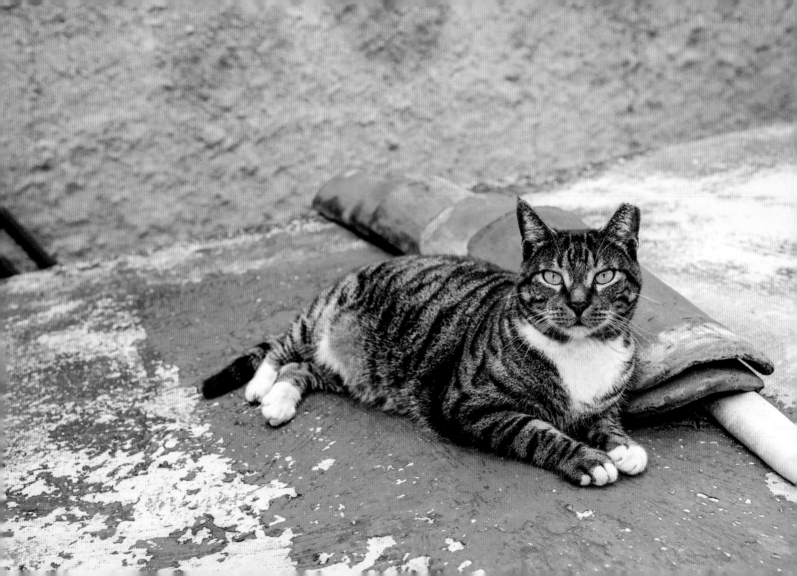

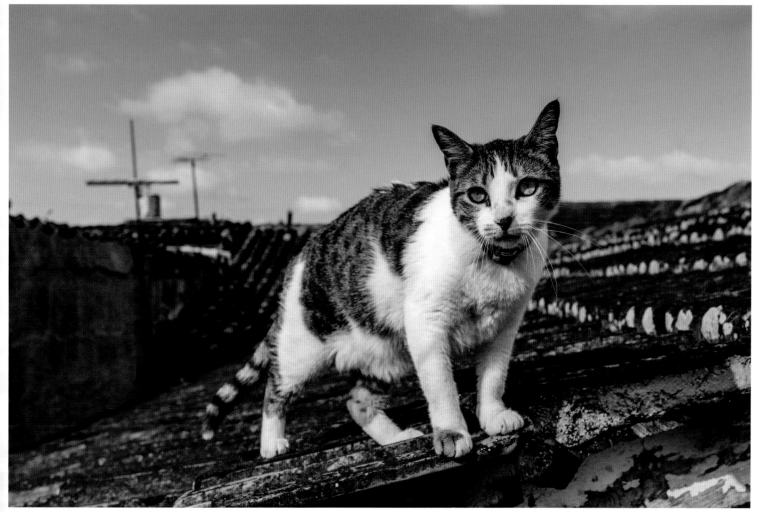

Gato, Cárdenas, Matanzas

Marina, Cárdenas, Matanzas

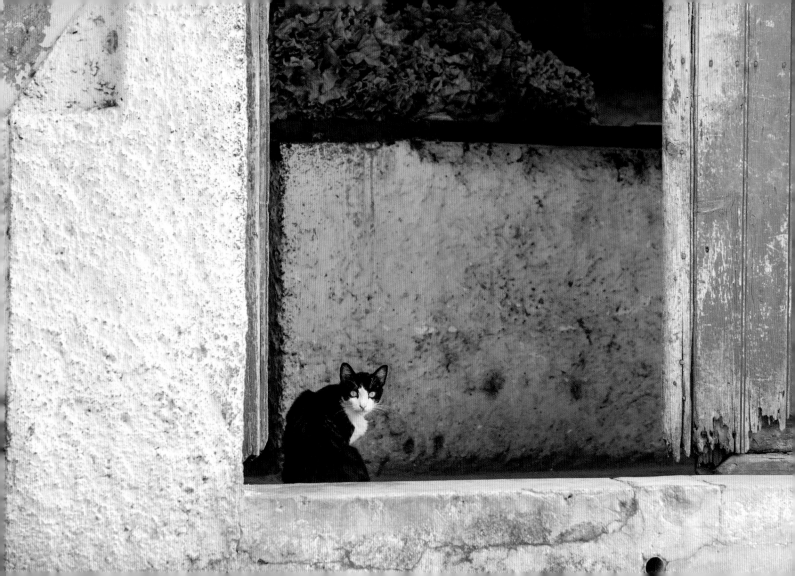

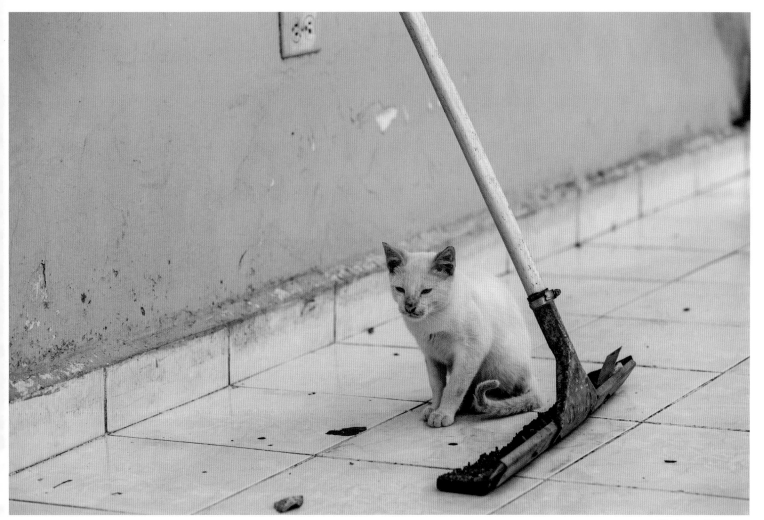

Cárdenas, Matanzas

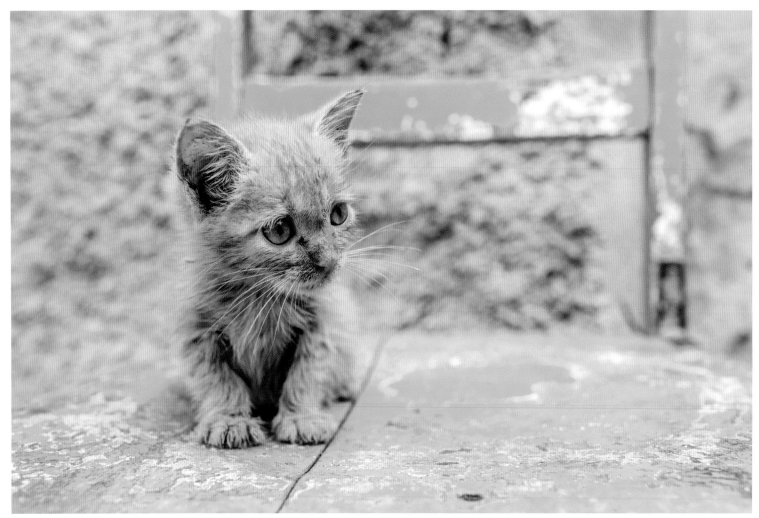

All People for Animals in Cuba (APAC), Cárdenas, Matanzas

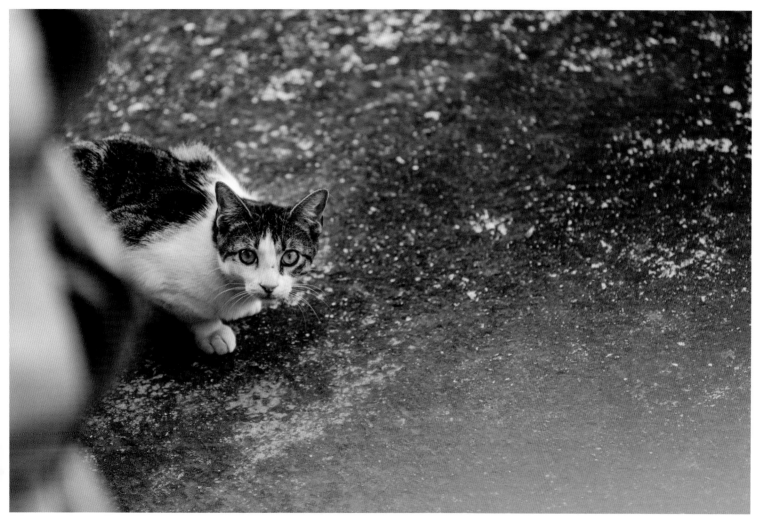

Marina, Cárdenas, Matanzas

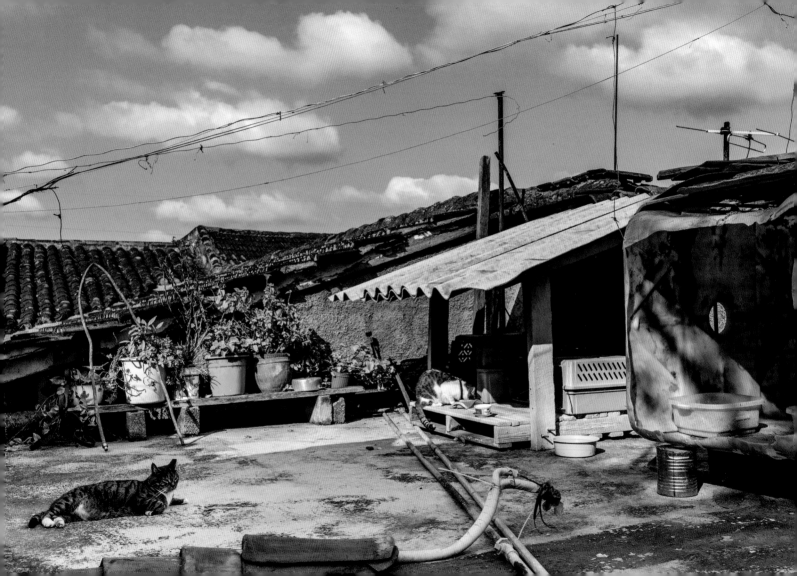

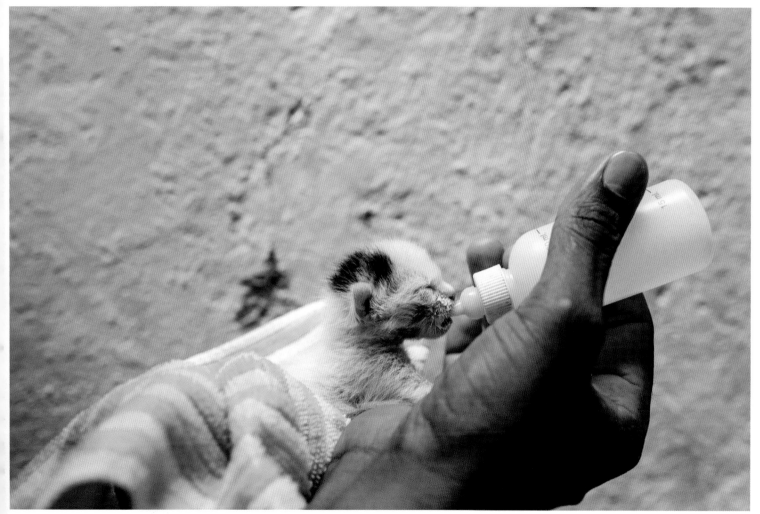

Gato y Marina, Cárdenas, Matanzas

All People for Animals in Cuba (APAC), Cárdenas, Matanzas

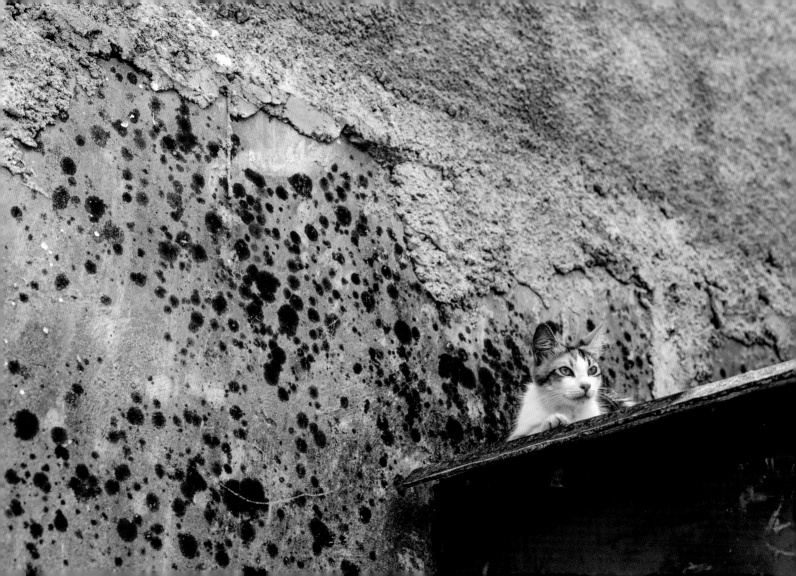

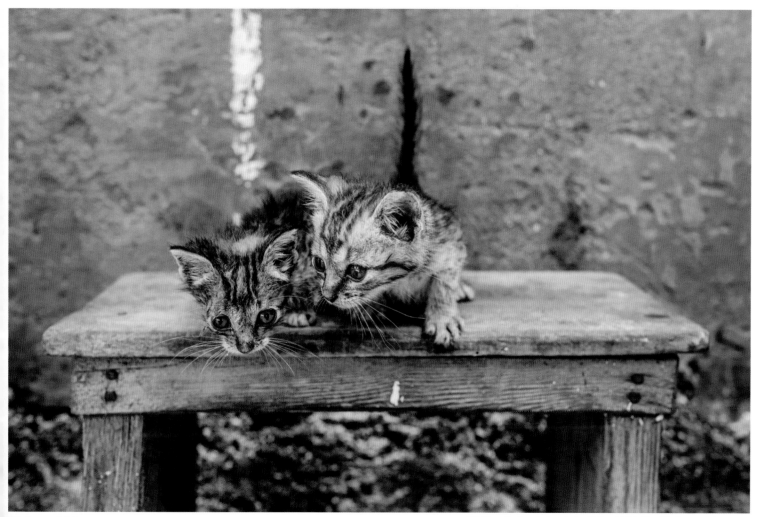

Cárdenas, Matanzas

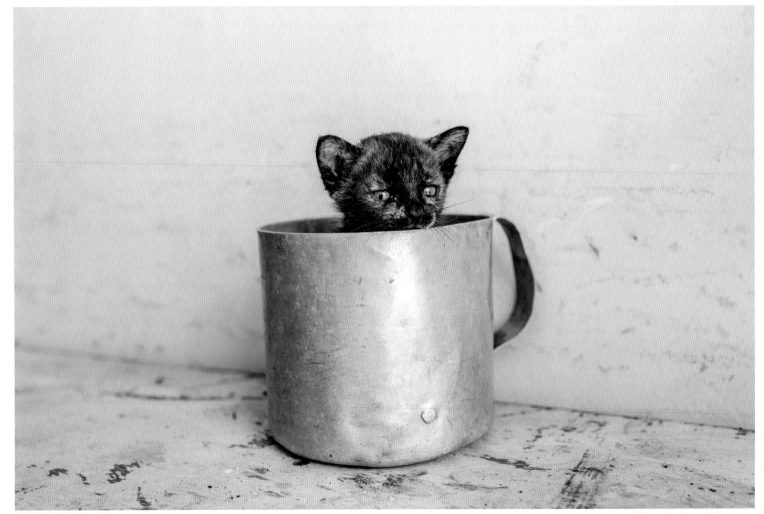

All People for Animals in Cuba (APAC), Cárdenas, Matanzas

Misu, Cárdenas, Matanzas

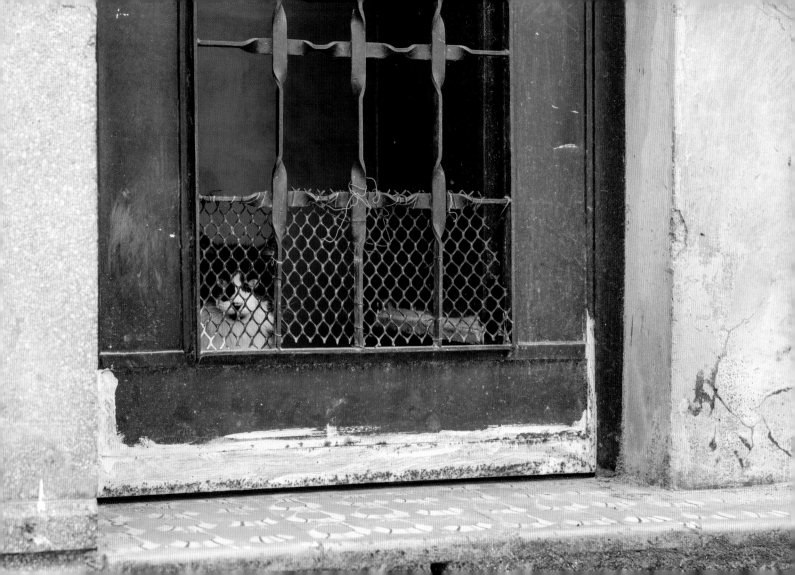

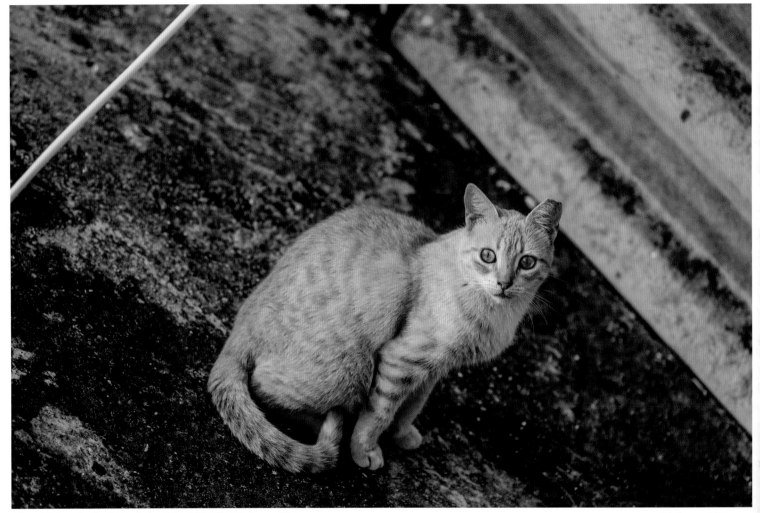

Cleo, All People for Animals in Cuba (APAC), Cárdenas, Matanzas

Cárdenas, Matanzas

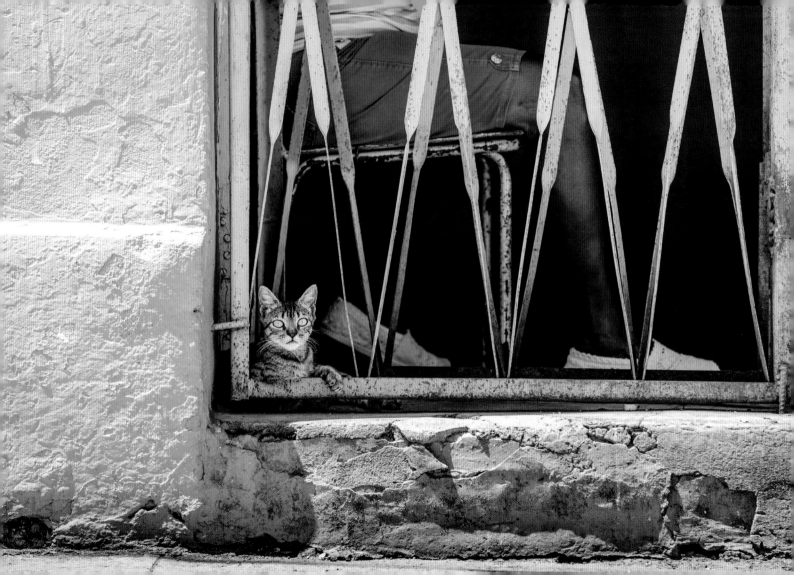

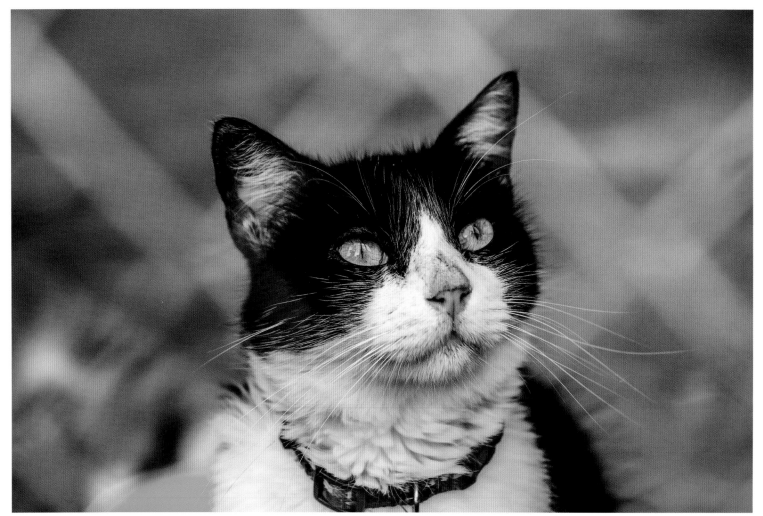

Dr. Gladis Corria Ochoa (veterinaria), Santa Marta, Matanzas

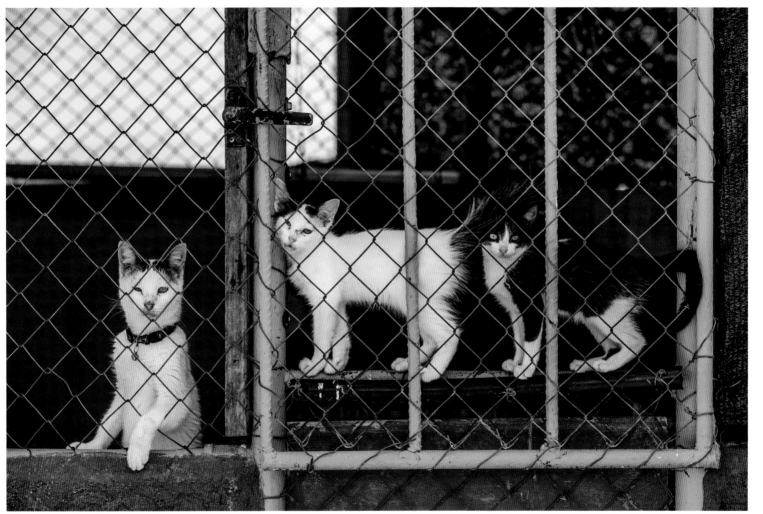

Dr. Gladis Corria Ochoa (veterinaria), Santa Marta, Matanzas

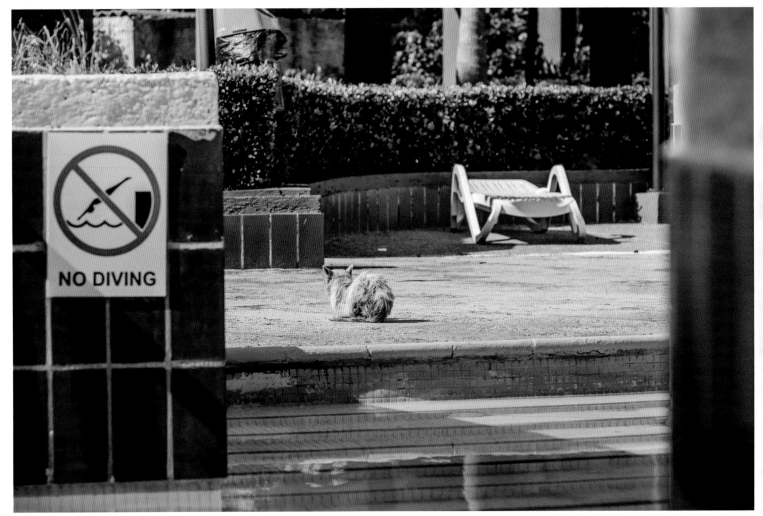

Varadero, Matanzas

Camilo Cienfuegos (Hershey), Mayabeque

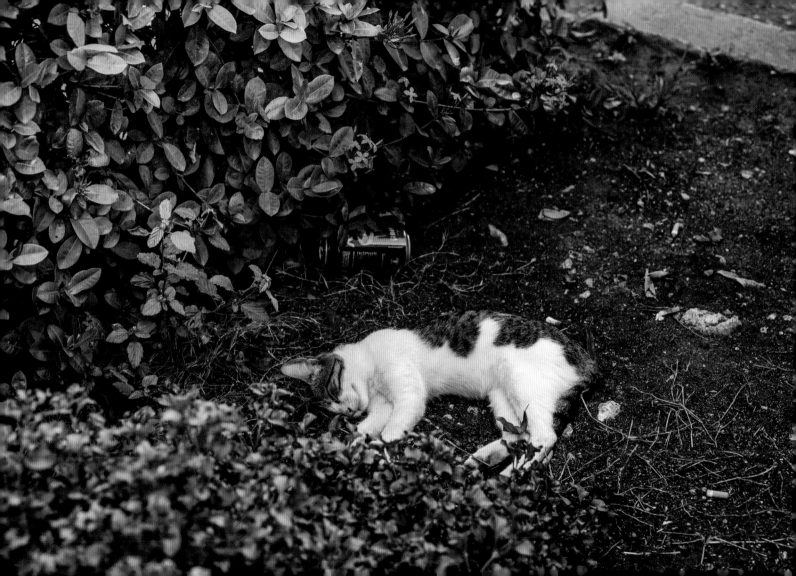

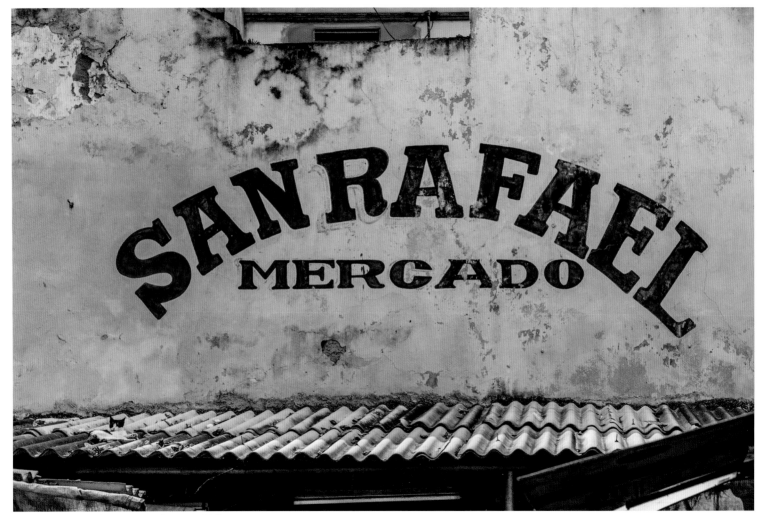

San Rafael Mercado, Centro Habana, La Habana

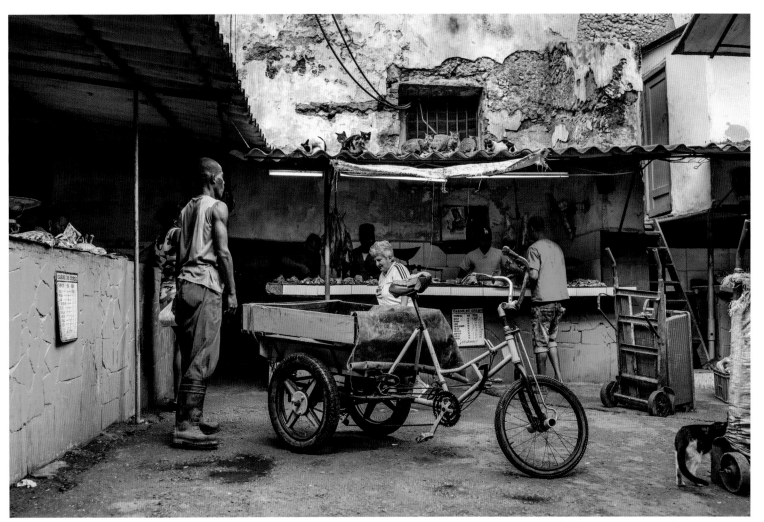

San Rafael Mercado, Centro Habana, La Habana

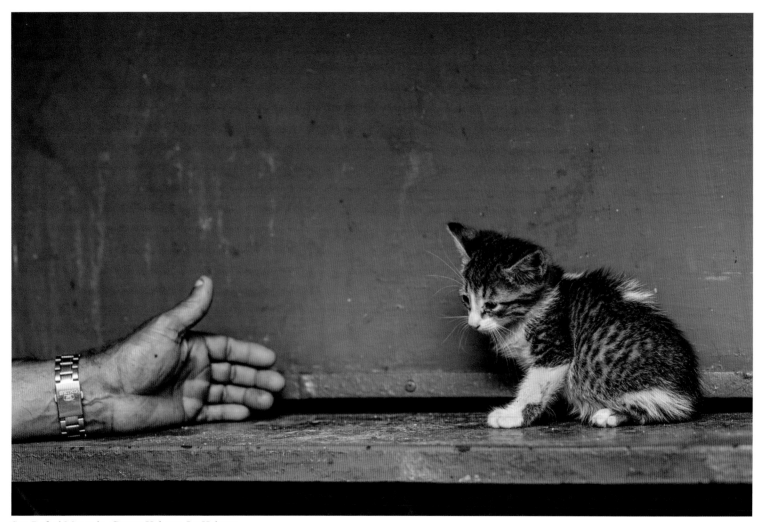

San Rafael Mercado, Centro Habana, La Habana

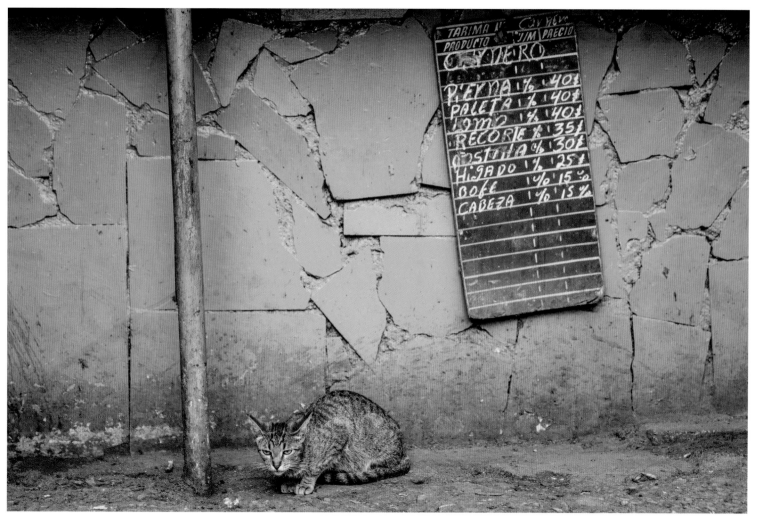

San Rafael Mercado, Centro Habana, La Habana

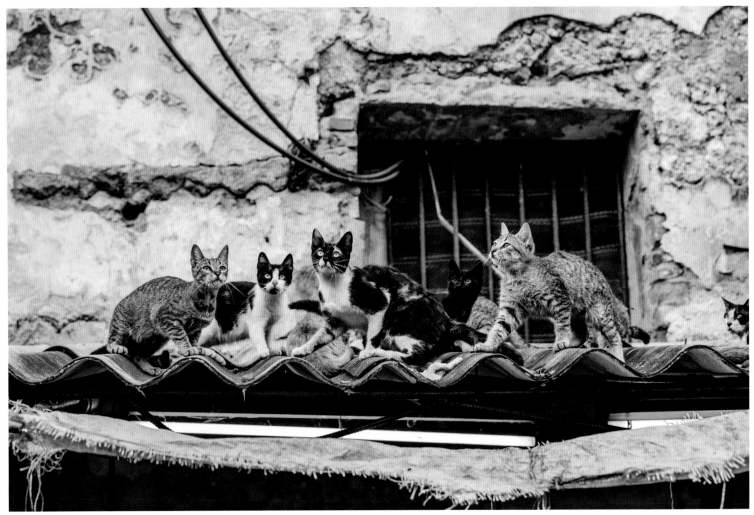

San Rafael Mercado, Centro Habana, La Habana

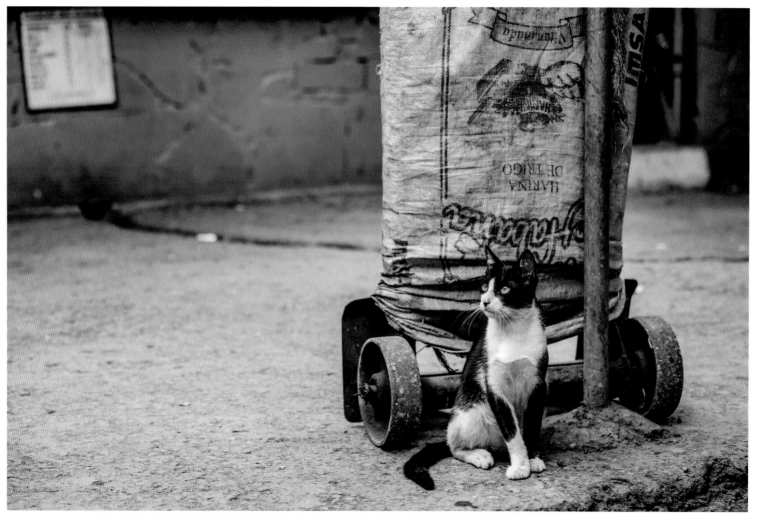

San Rafael Mercado, Centro Habana, La Habana

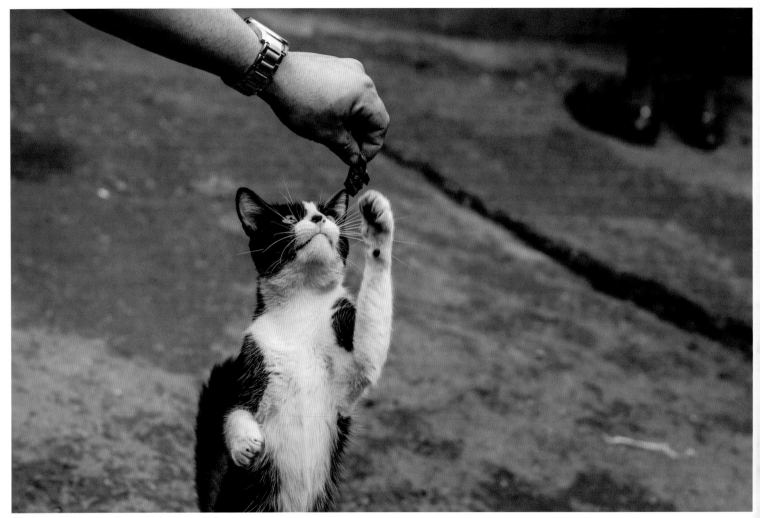

San Rafael Mercado, Centro Habana, La Habana

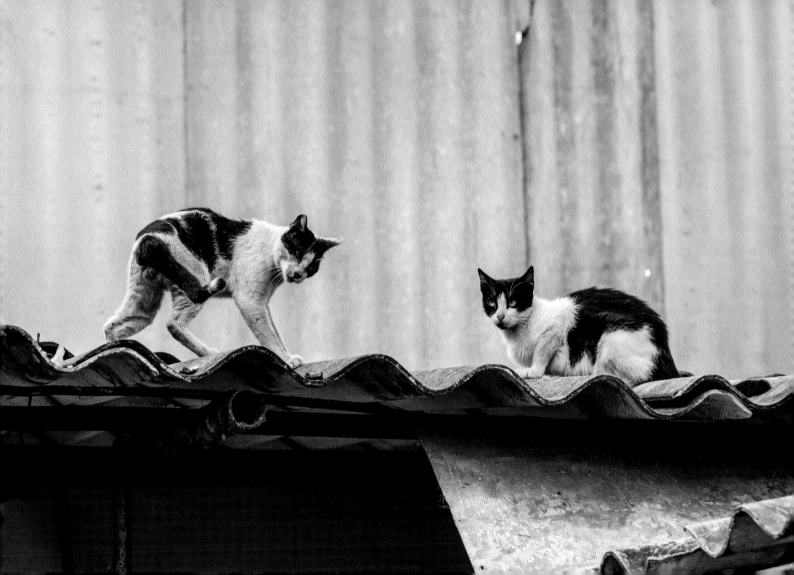

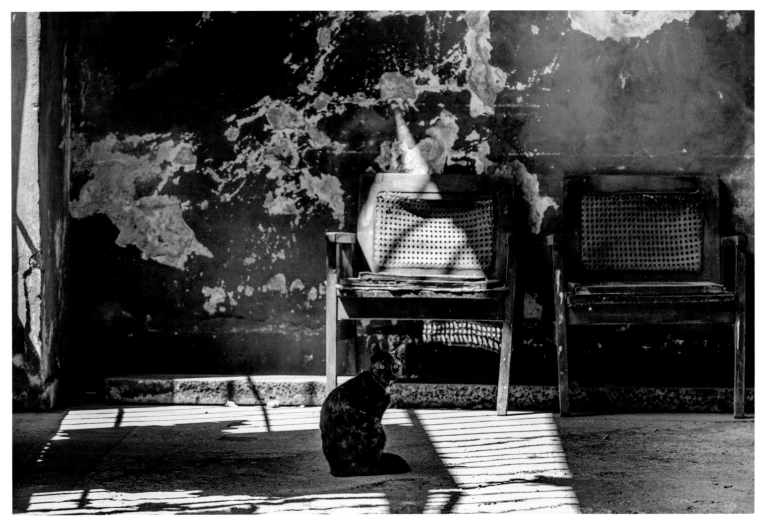

Mona, Centro Habana, La Habana

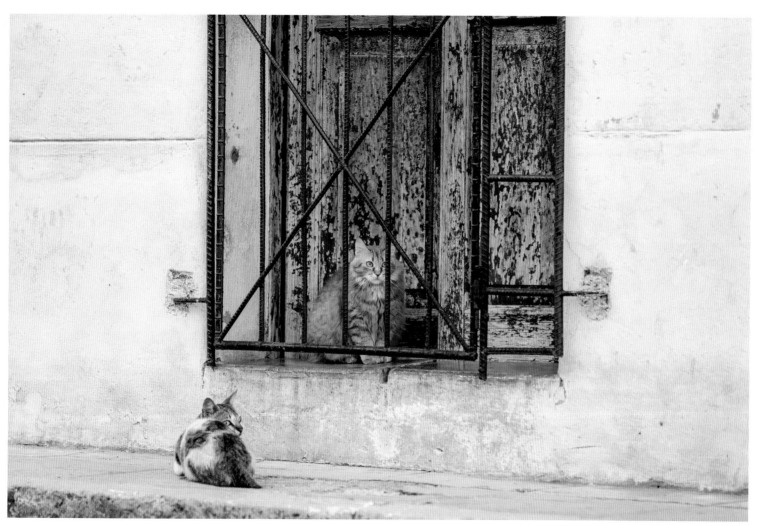

Centro Habana, La Habana

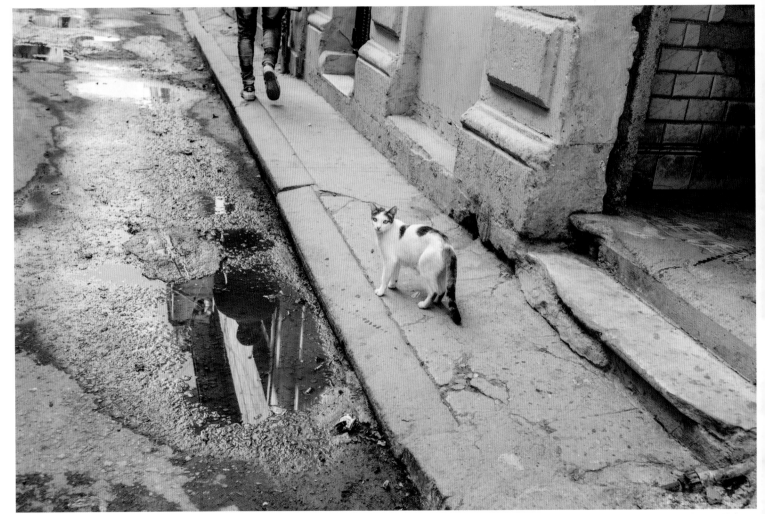

Centro Habana, La Habana

Habana Vieja, La Habana

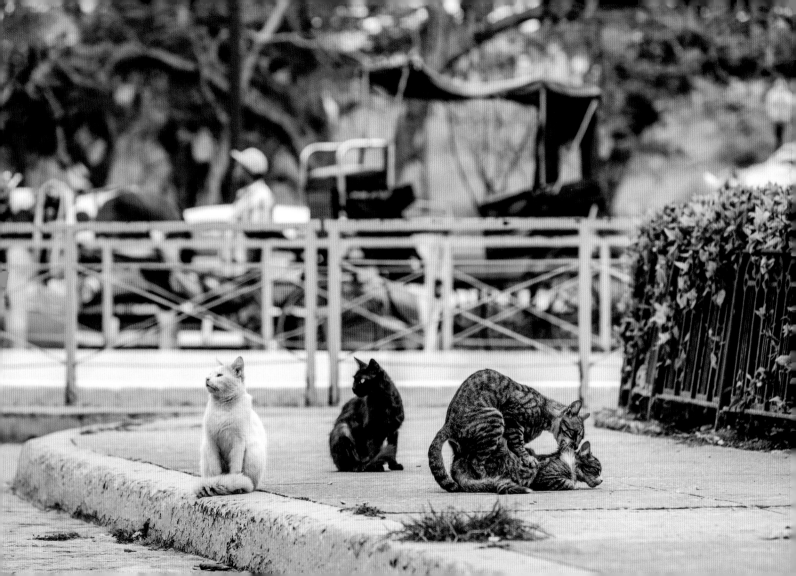

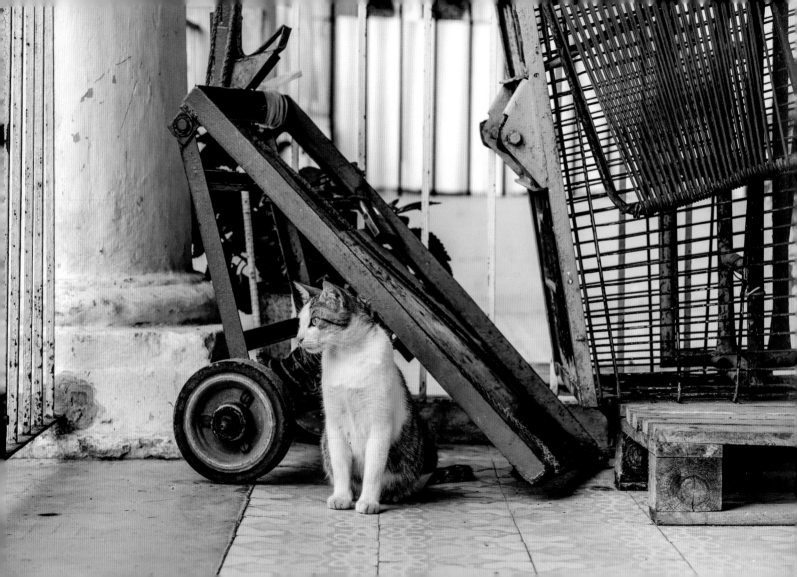

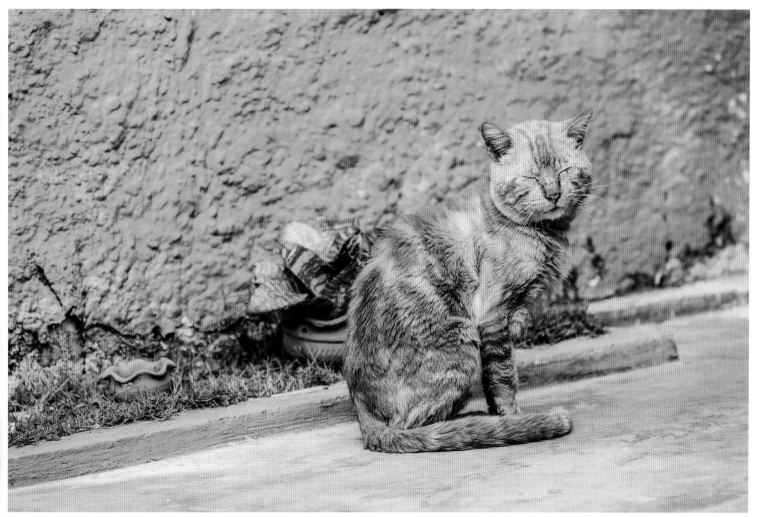

Lawton, La Habana

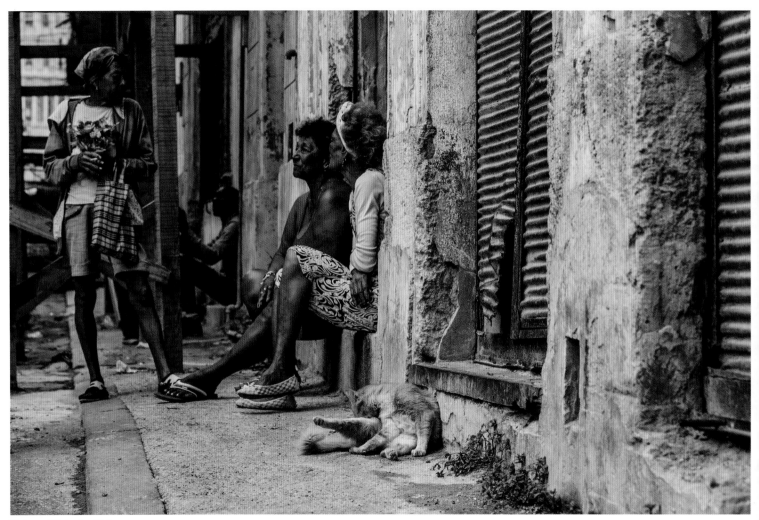

Habana Vieja, La Habana

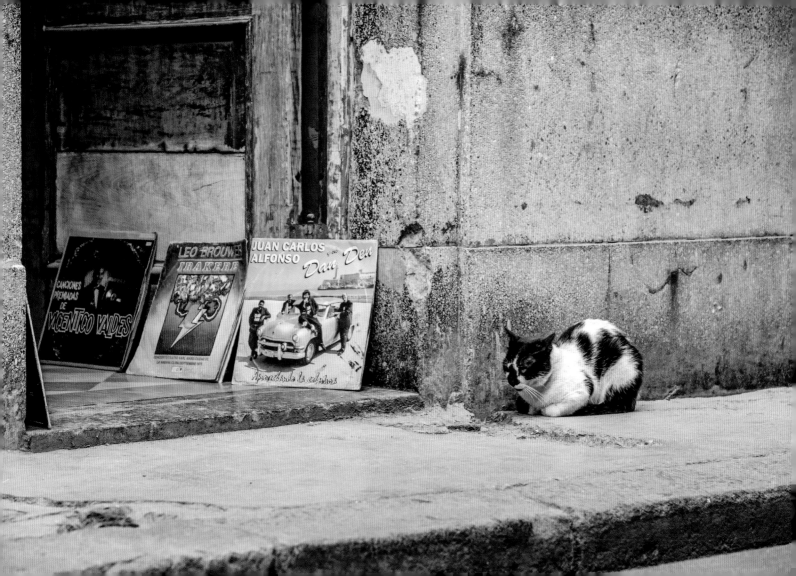

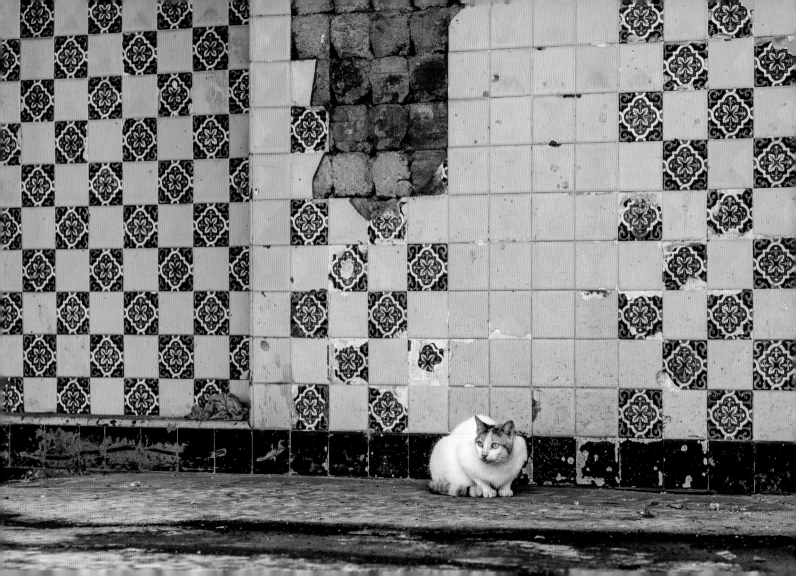

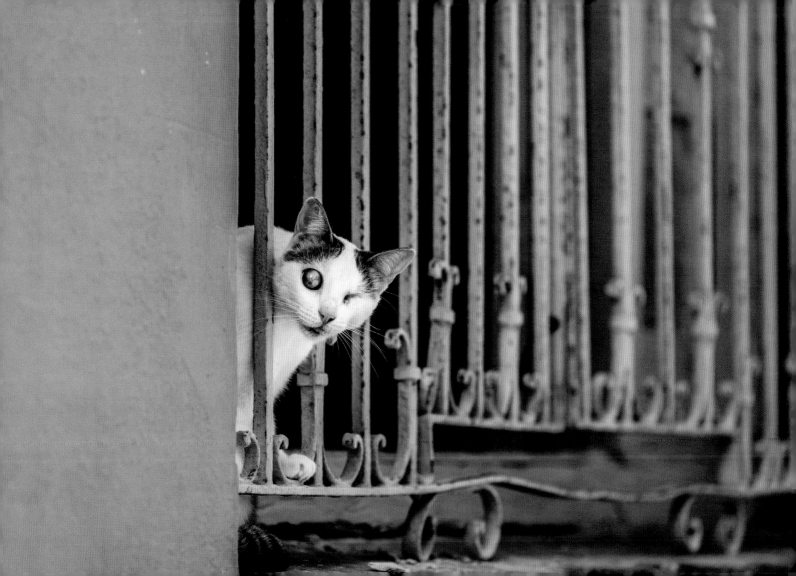

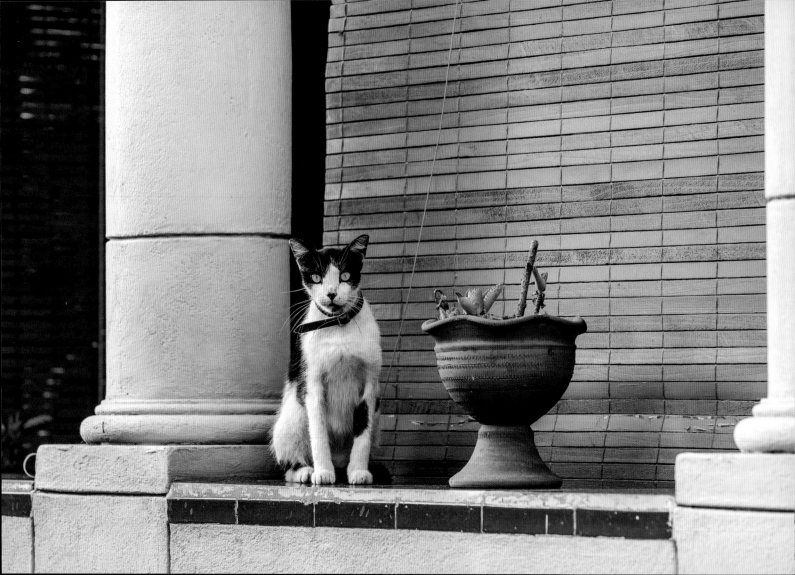

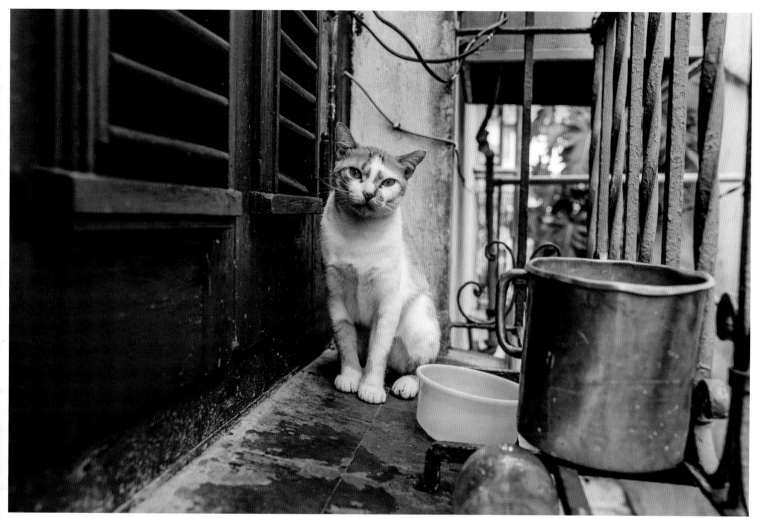

Blanco y Negro, Vedado, La Habana

Misa, Cubanos en Defensa de los Animales (CEDA), Vedado, La Habana

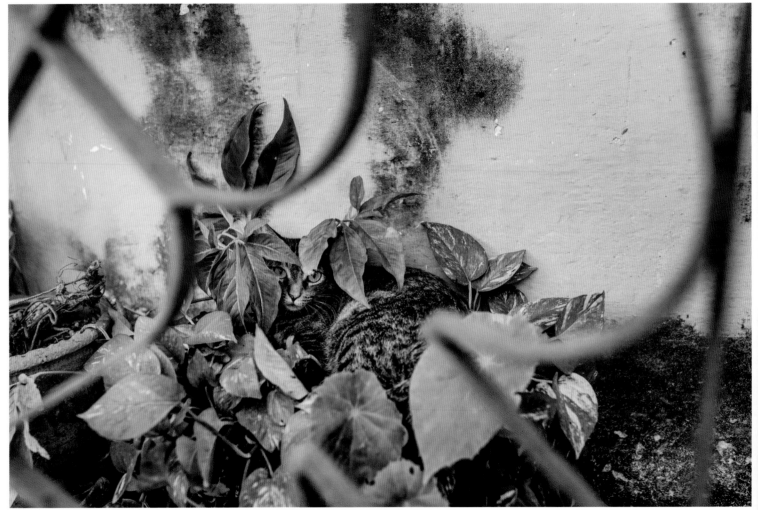

Cerro, La Habana

Tomás, Plaza, La Habana

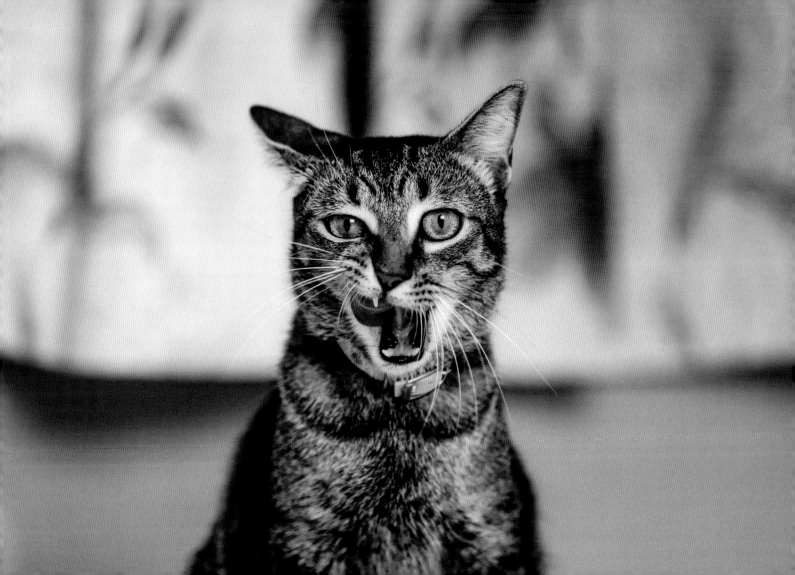

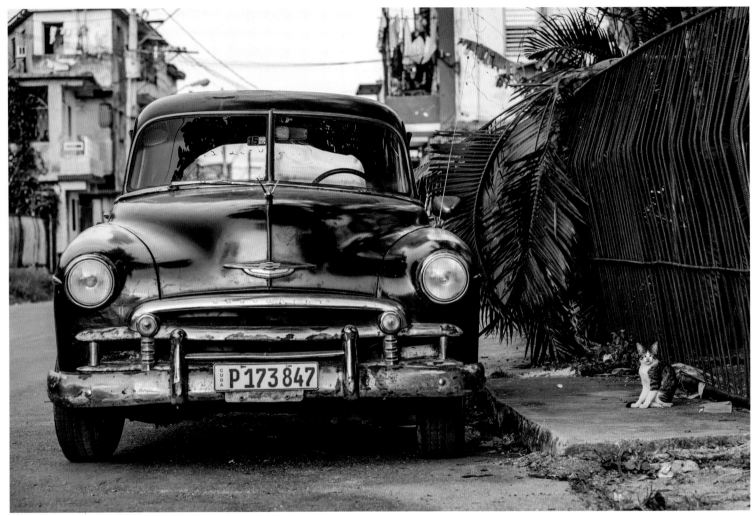

Cerro, La Habana

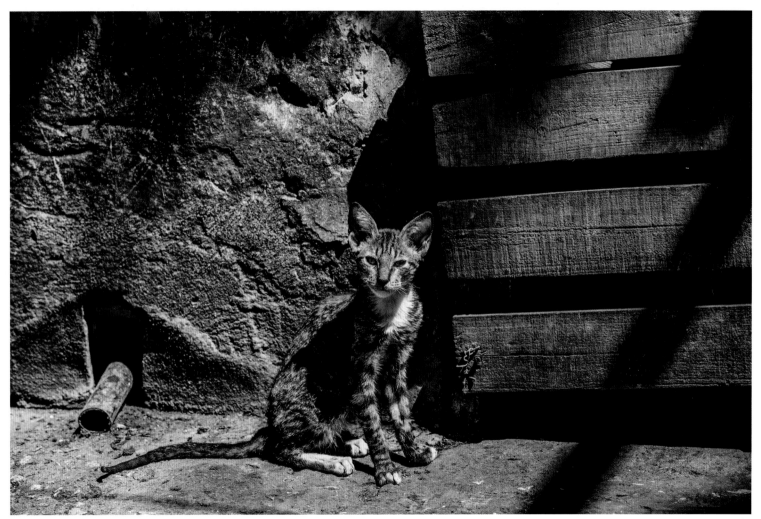

Cerro, La Habana

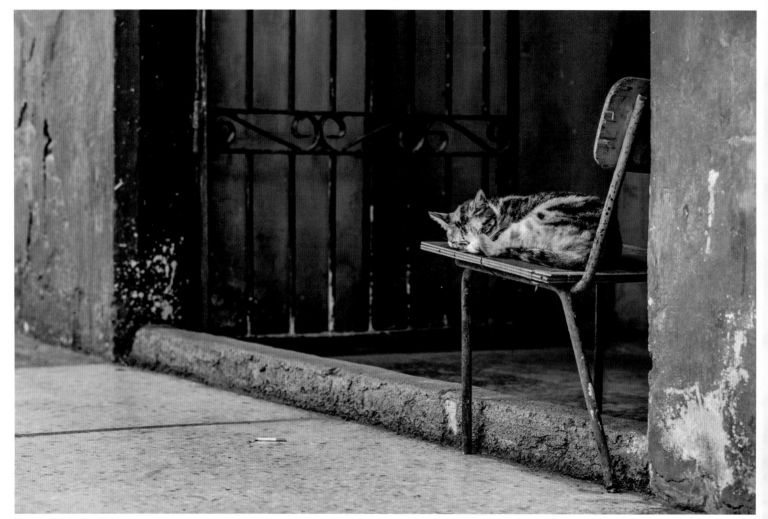

Habana Vieja, La Habana

Regla, La Habana

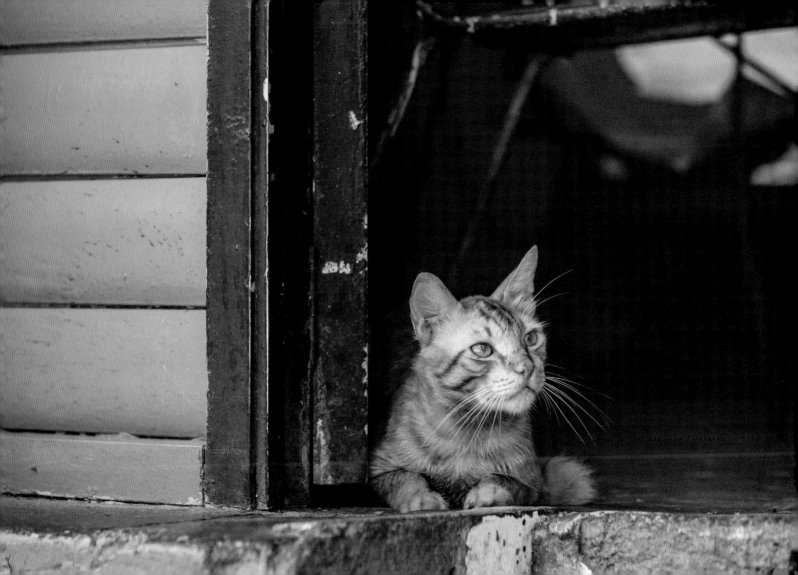

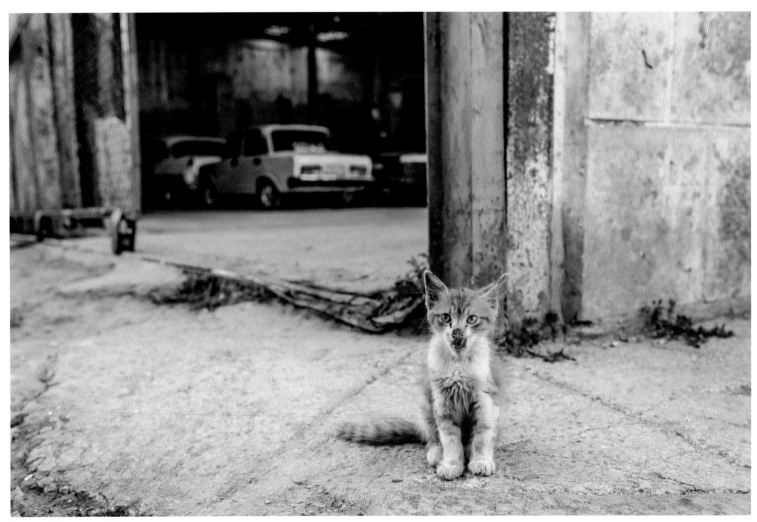

Centro Habana, La Habana

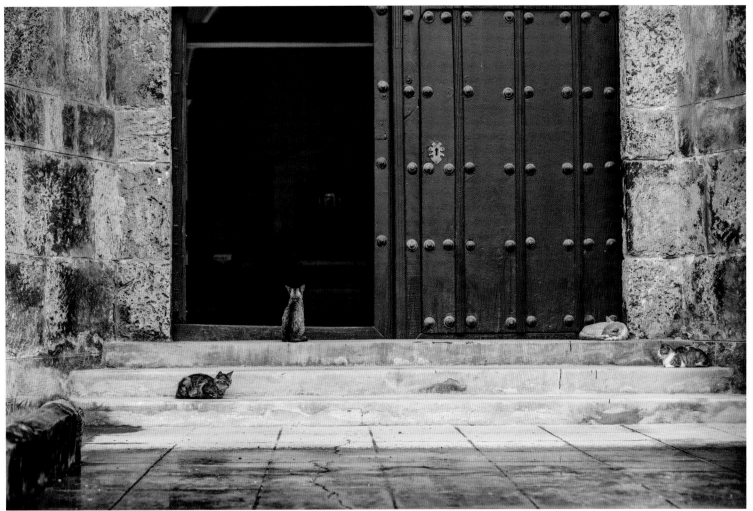

Iglesia del Santo Cristo del Buen Viaje, Habana Vieja, La Habana

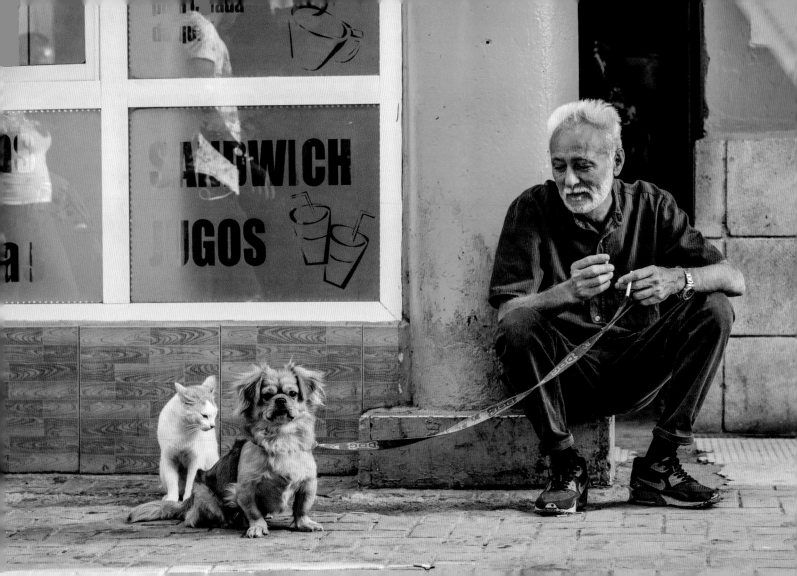

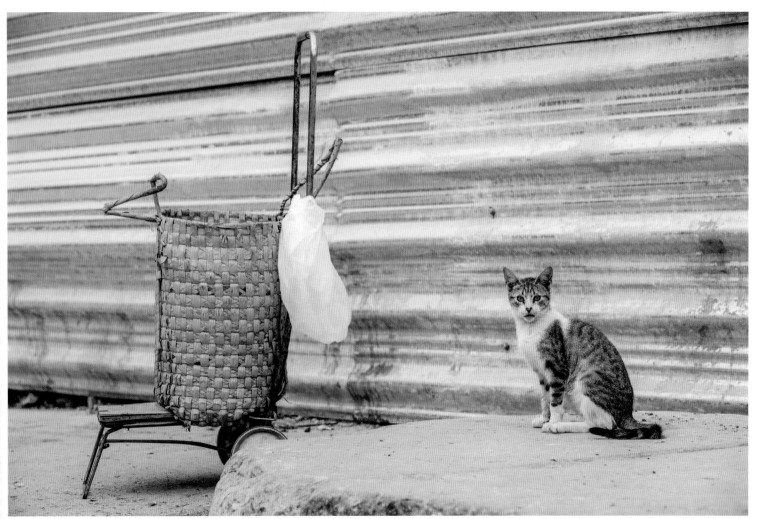

Habana Vieja, La Habana

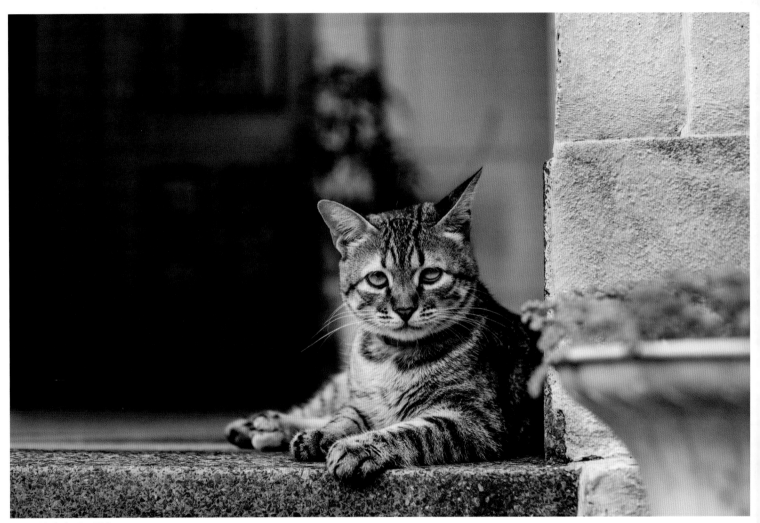

Mari, Vedado, La Habana

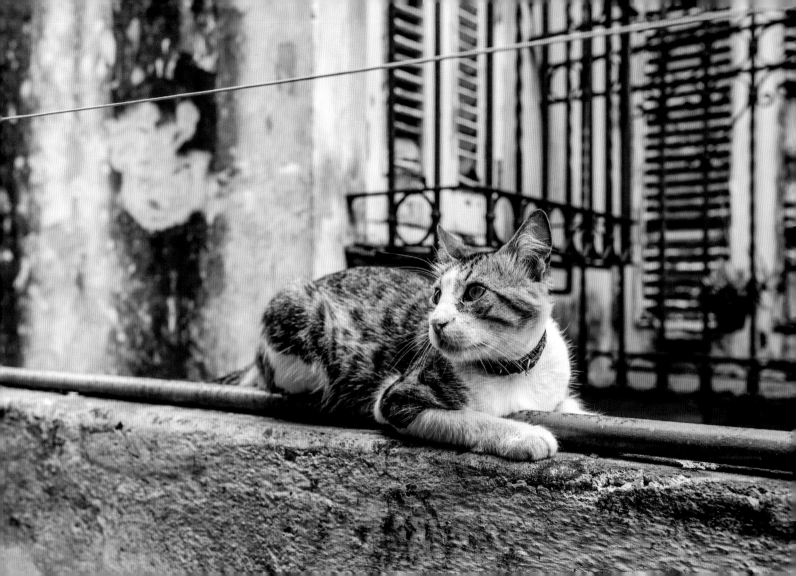

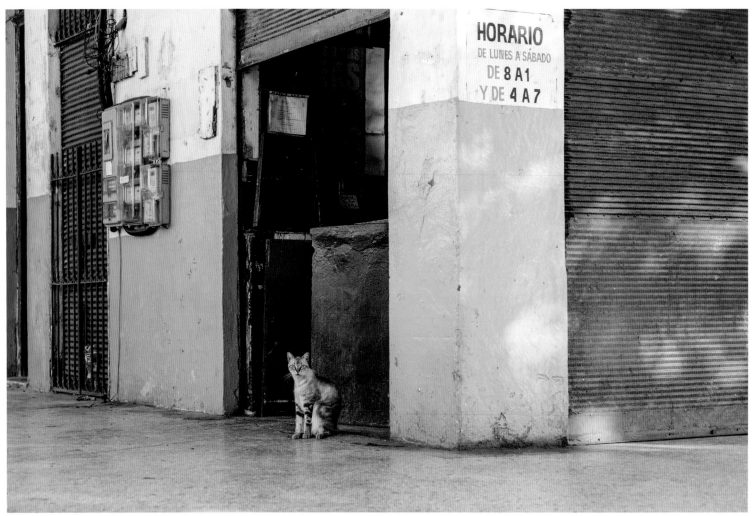

HORARIO
DE LUNES A SÁBADO
DE 8 A 1
Y DE 4 A 7

Calle 23, Vedado, La Habana

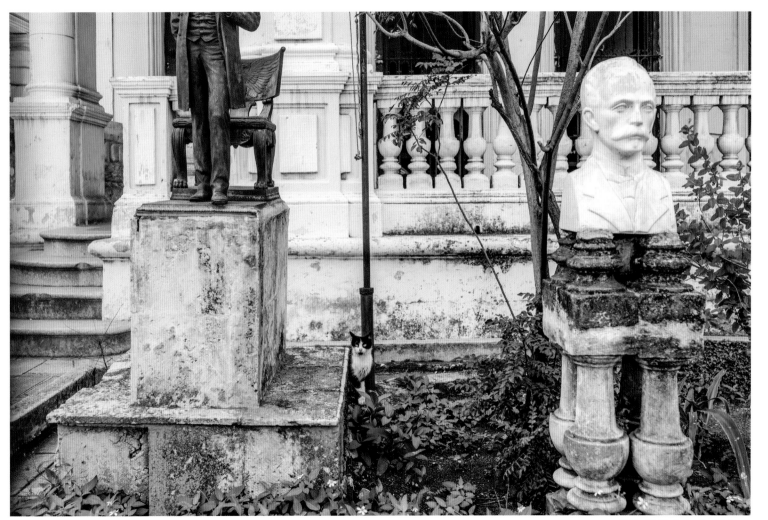

Calle G, Vedado, La Habana

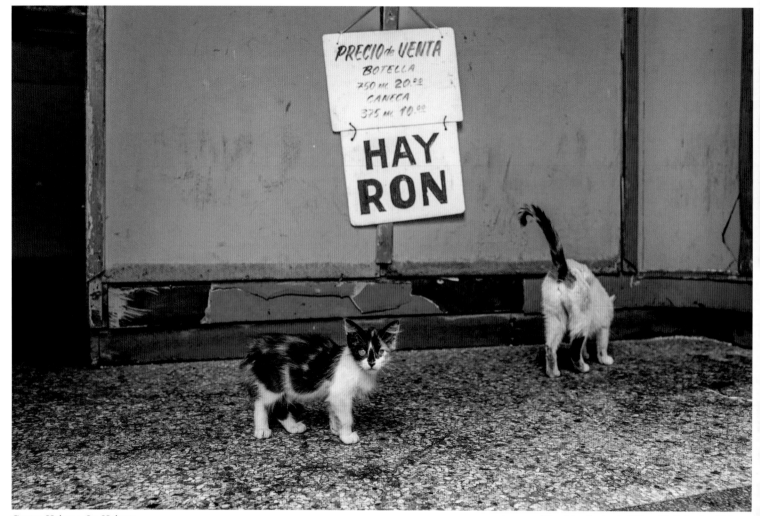

PRECIO de VENTA
BOTELLA
750 ml 20.⁰⁰
CANECA
375 ml 10.⁰⁰
HAY
RON

Centro Habana, La Habana

Mural by Ludovic Olivo, Vedado, La Habana

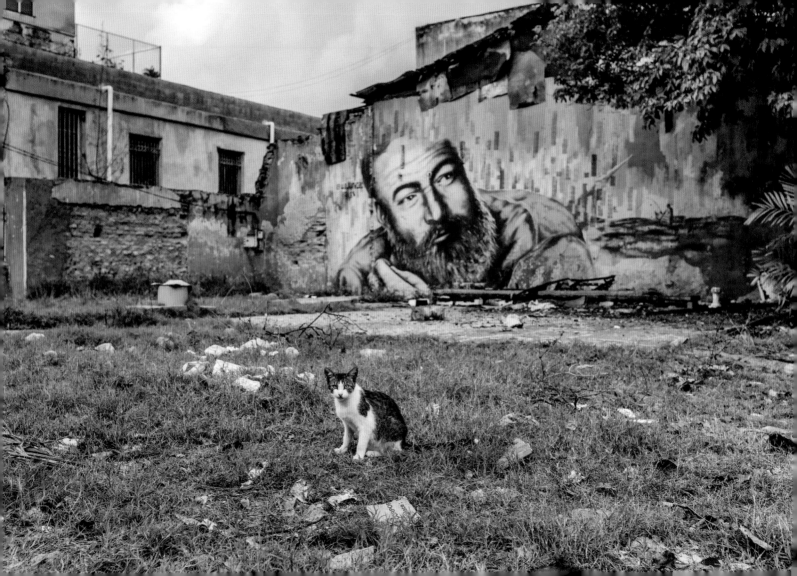

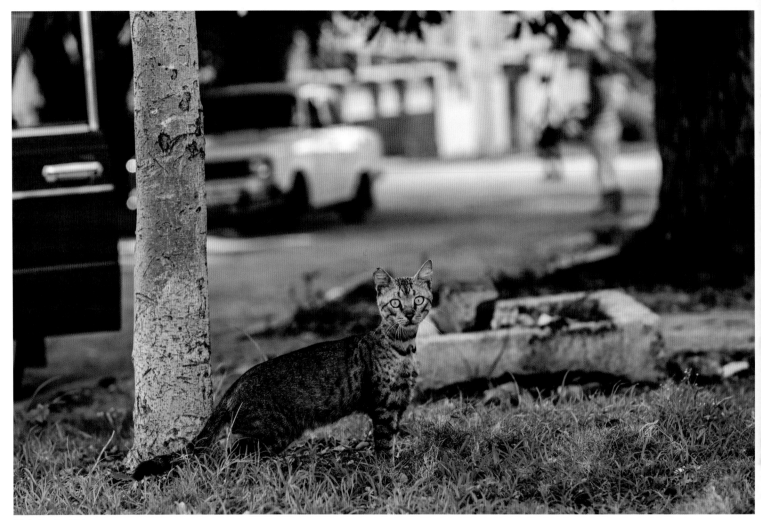

Vedado, La Habana

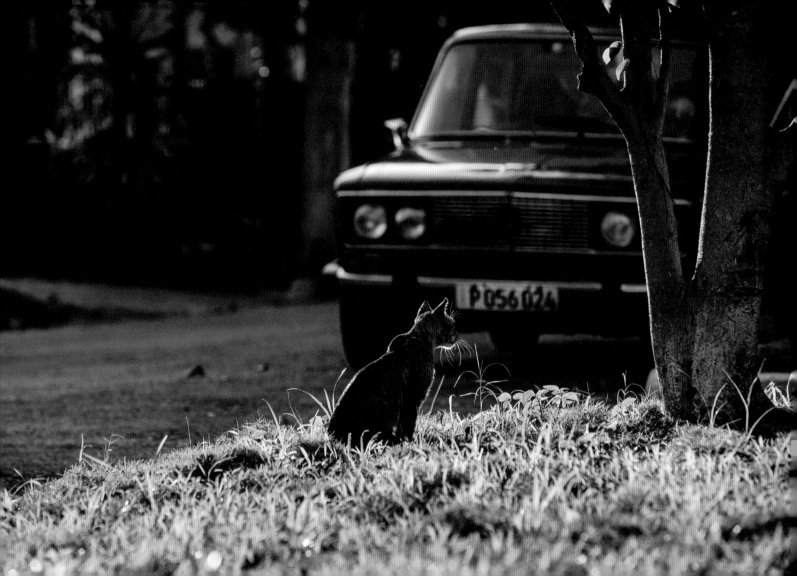

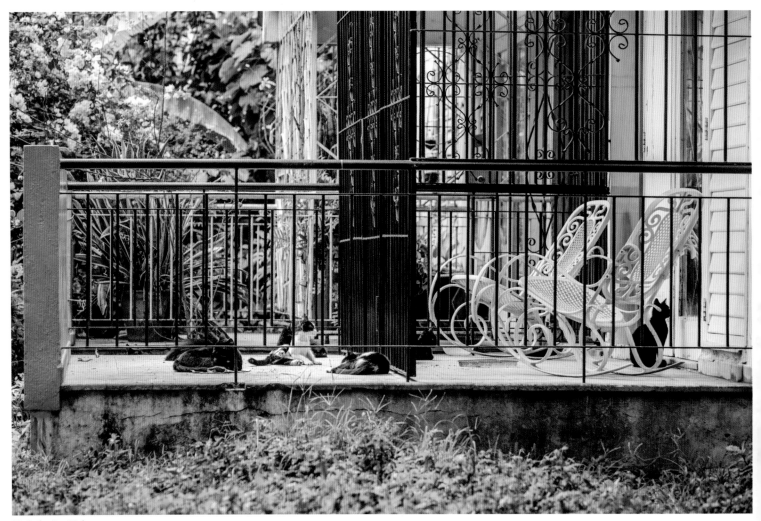

Vedado, La Habana

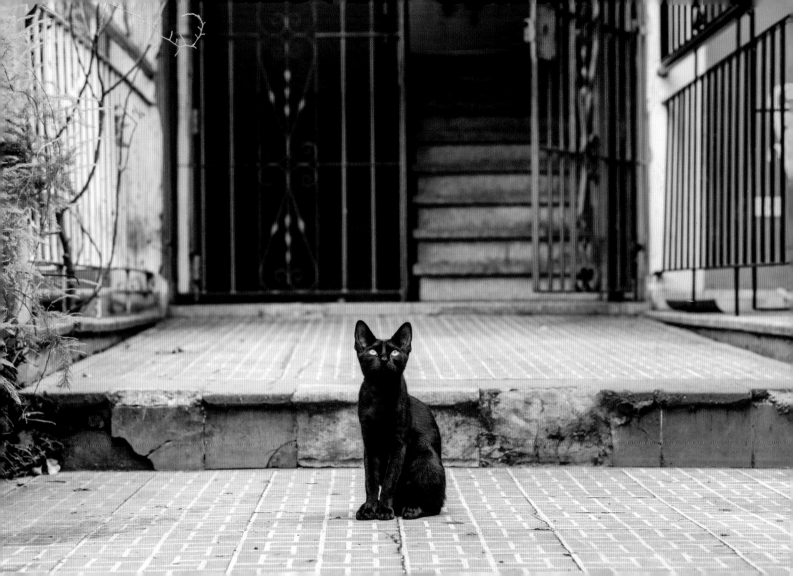

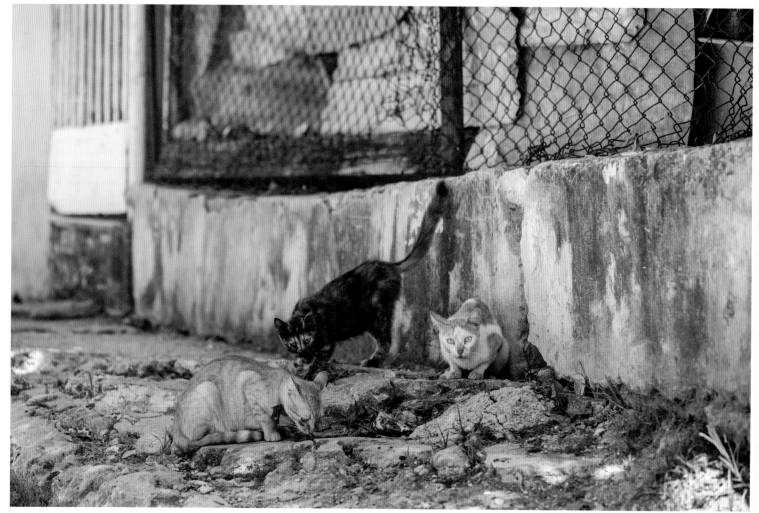

Cerro, La Habana

Vedado, La Habana

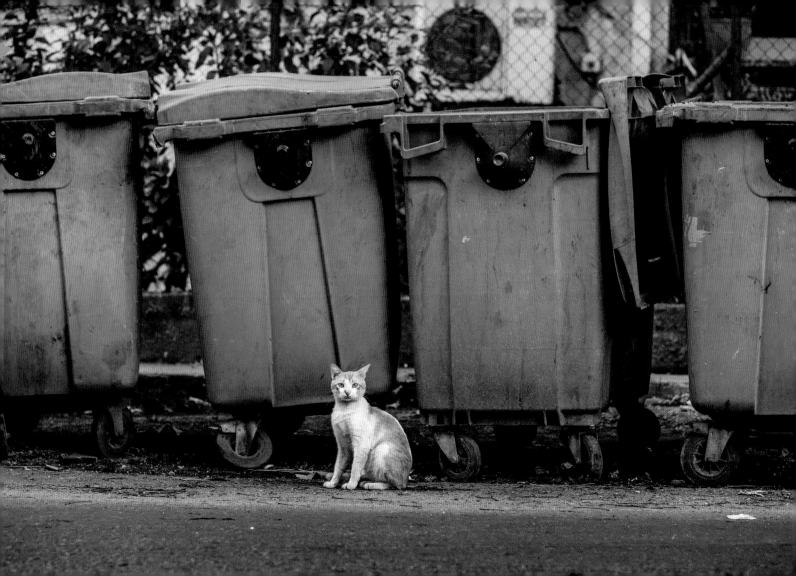

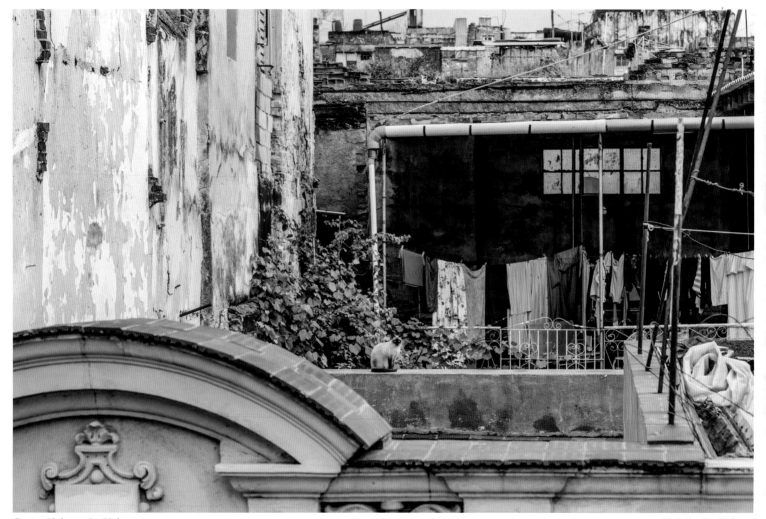

Centro Habana, La Habana

Vedado, La Habana

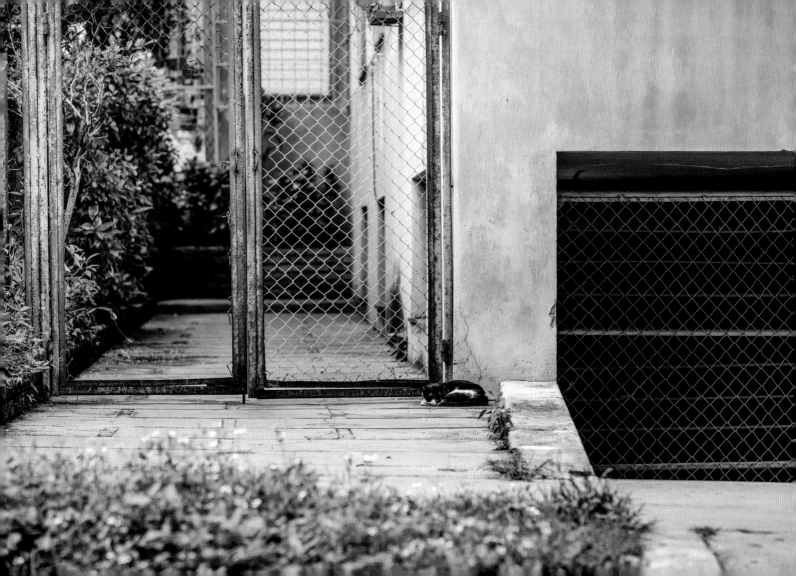

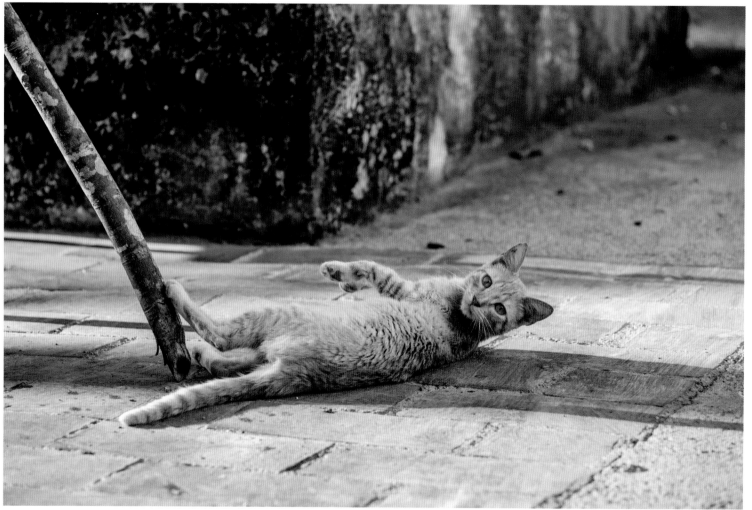

Las Terrazas, Artemisa

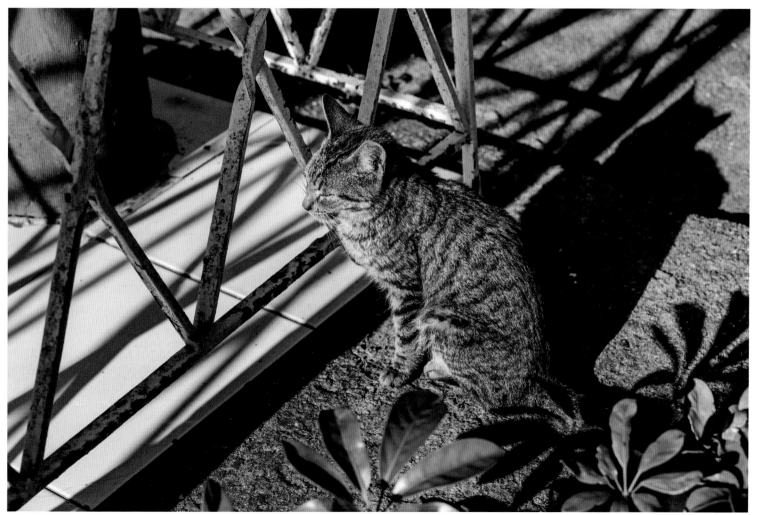

Las Terrazas, Artemisa

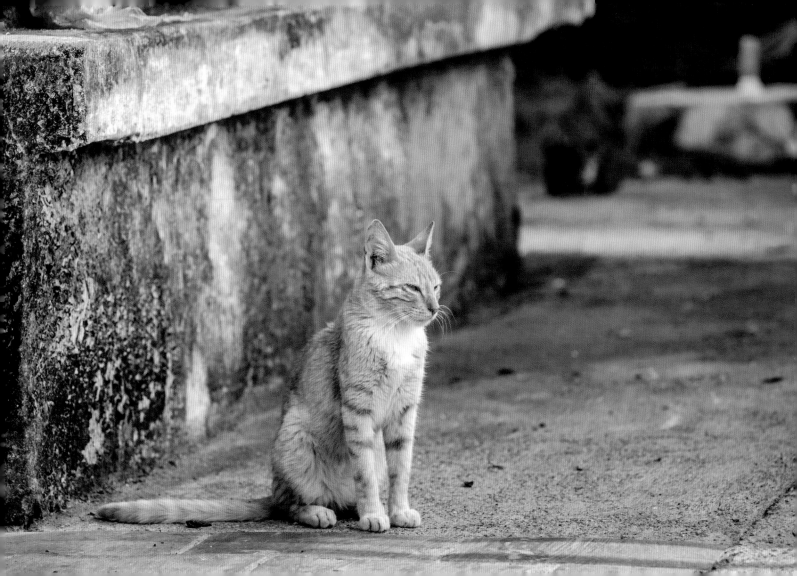

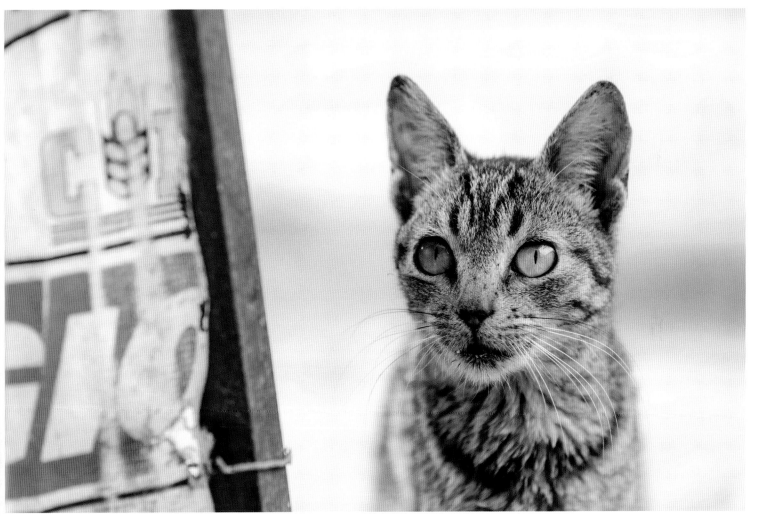

Las Terrazas, Artemisa

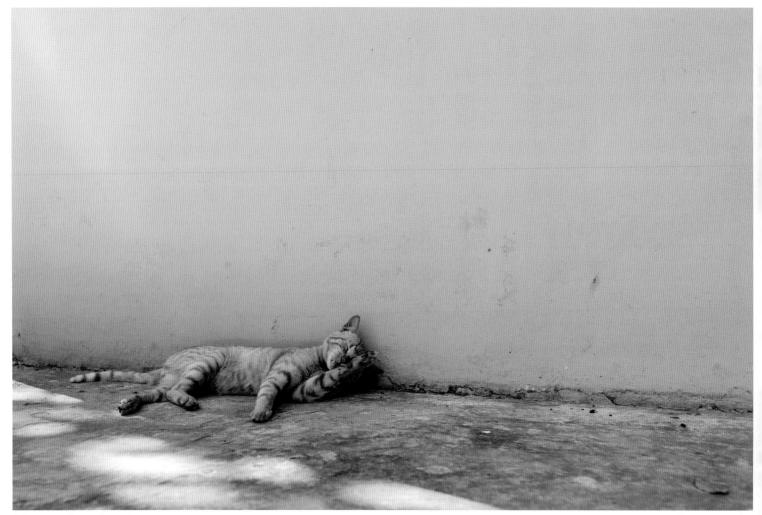

Mr. Trump, Soroa, Artemisa

Soroa, Artemisa

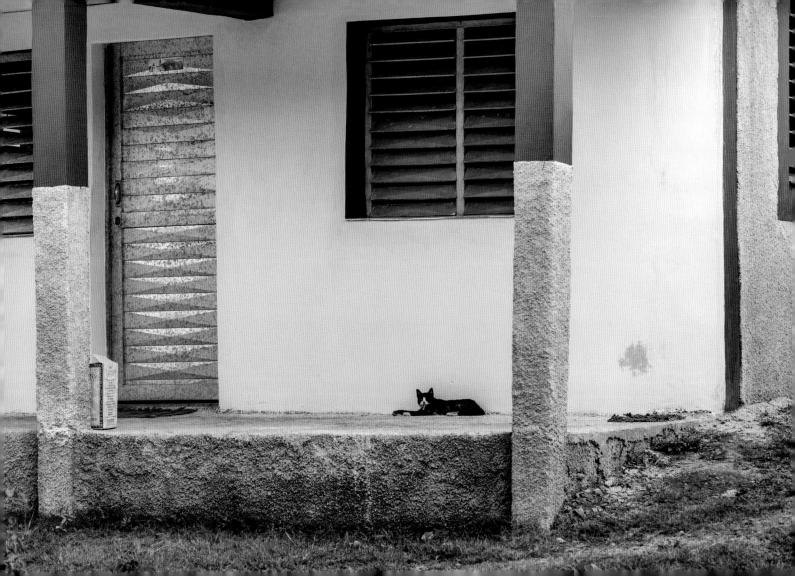

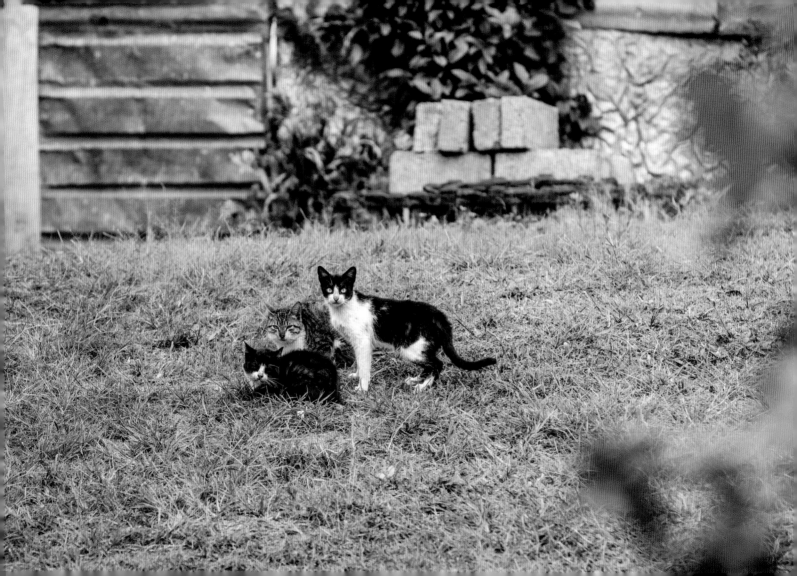

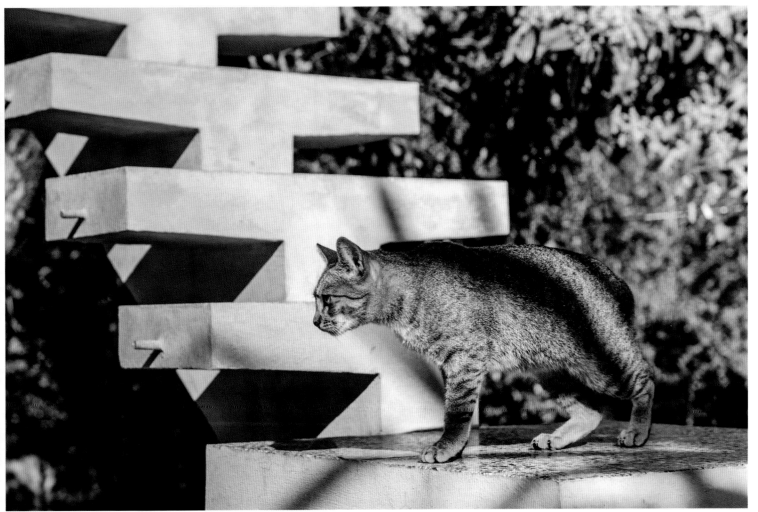

Soroa, Artemisa

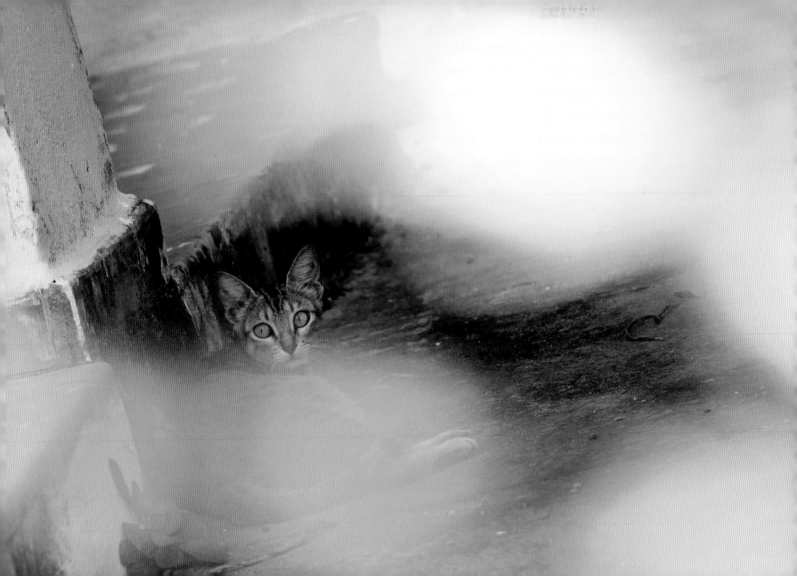

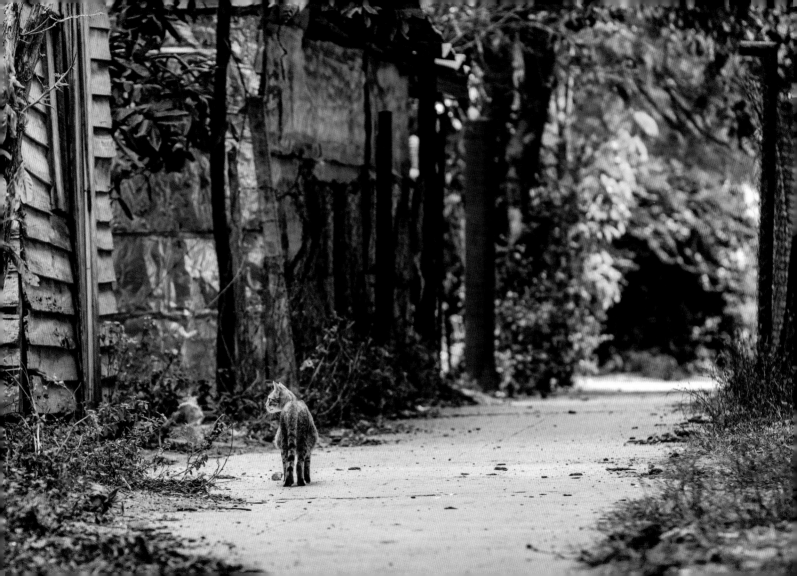

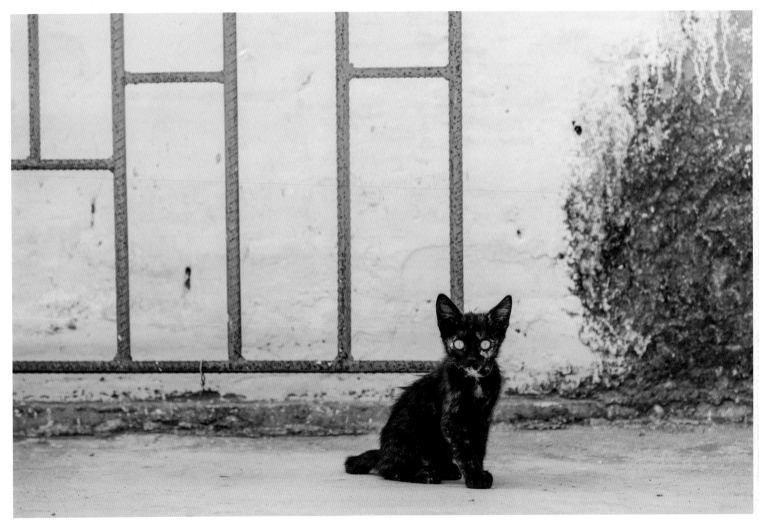

Briones Montoto, Pinar del Río

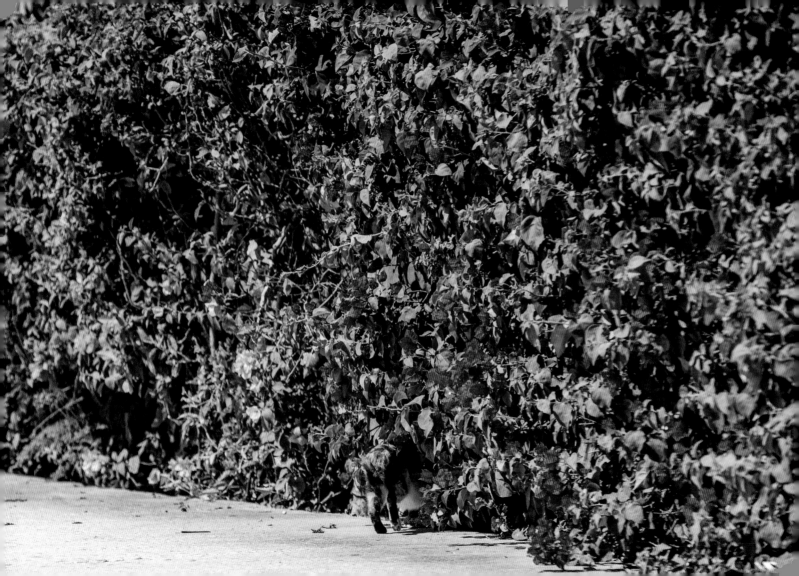

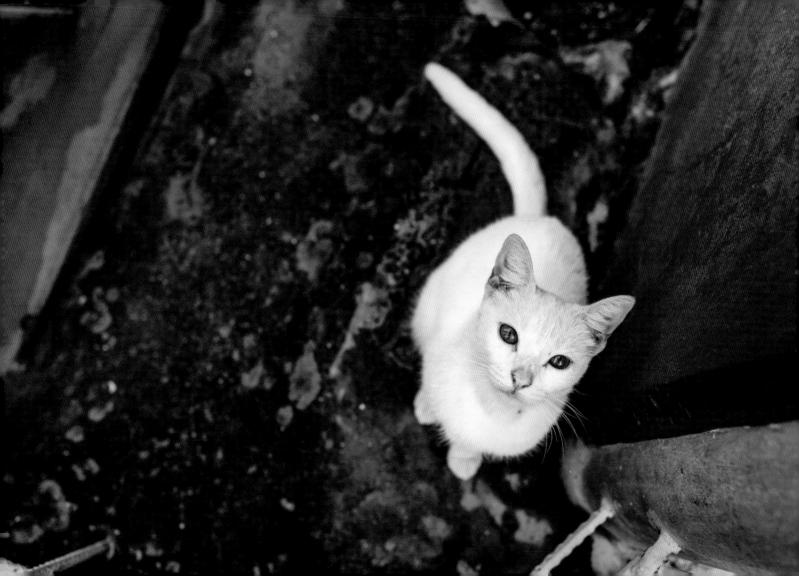

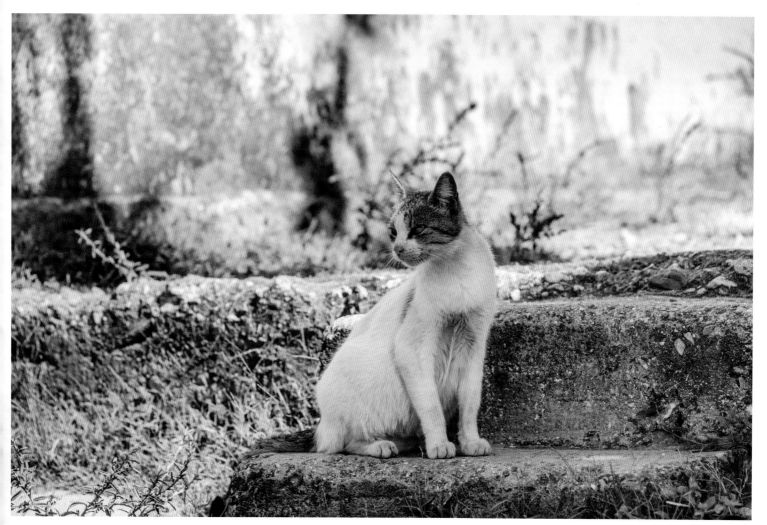

Pinar del Río, Pinar del Río

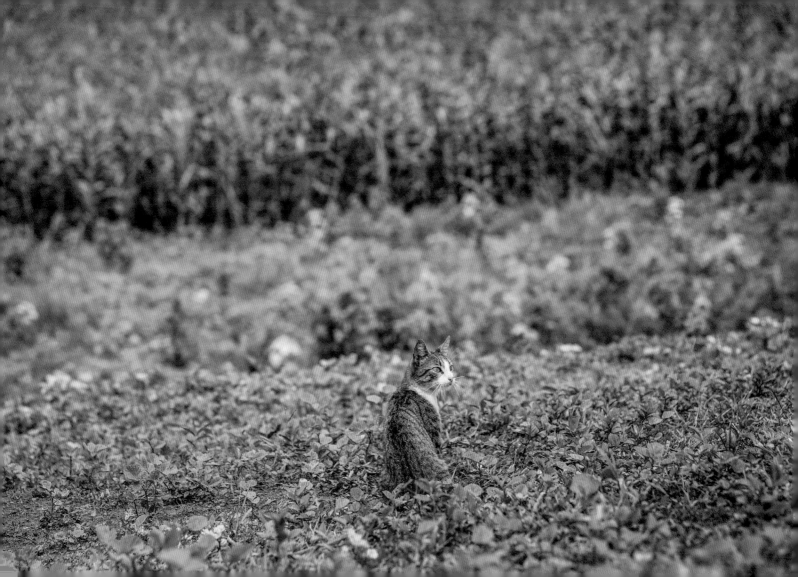

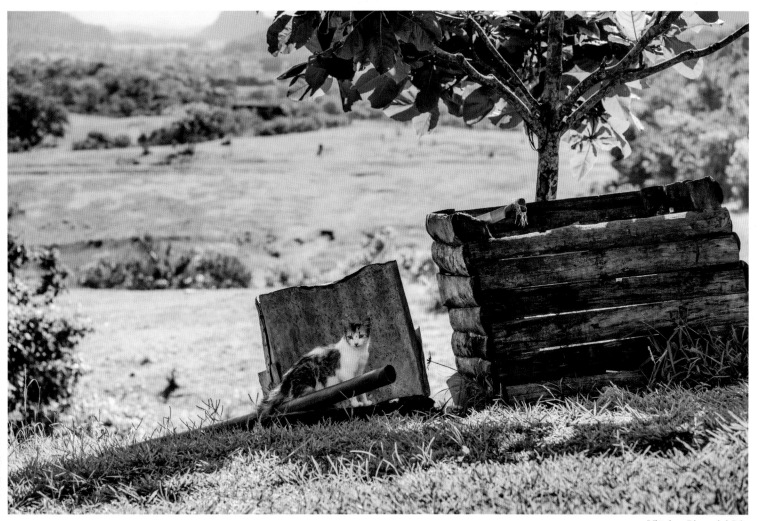

Viñales, Pinar del Río

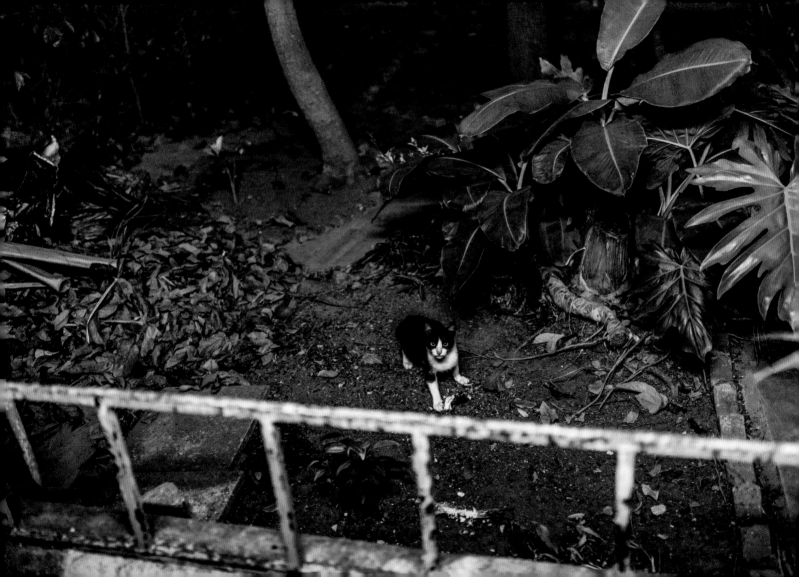

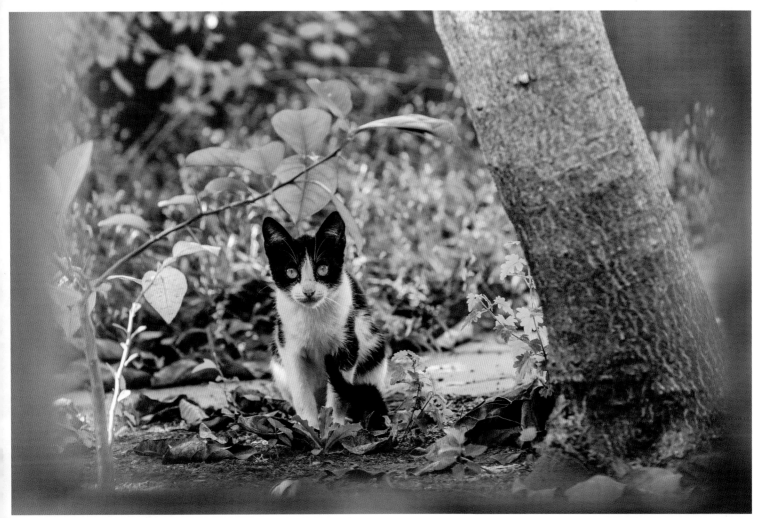

Nueva Gerona, Isla de la Juventud

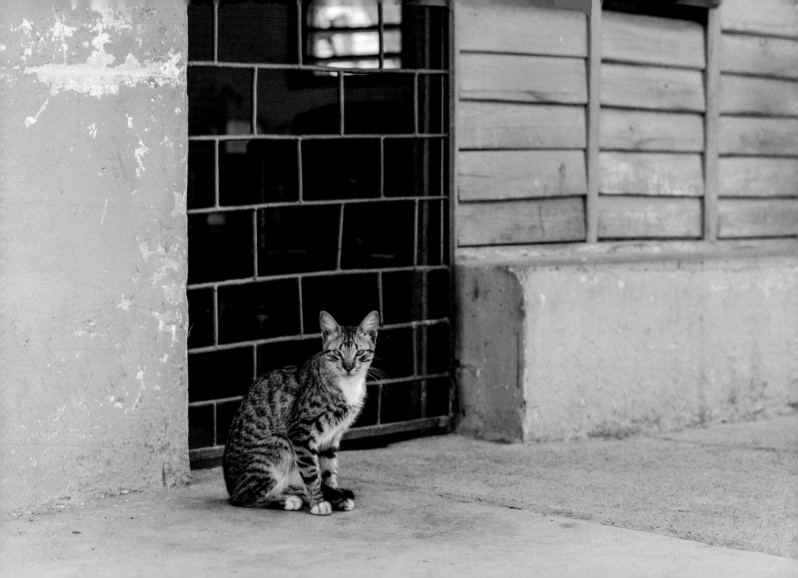

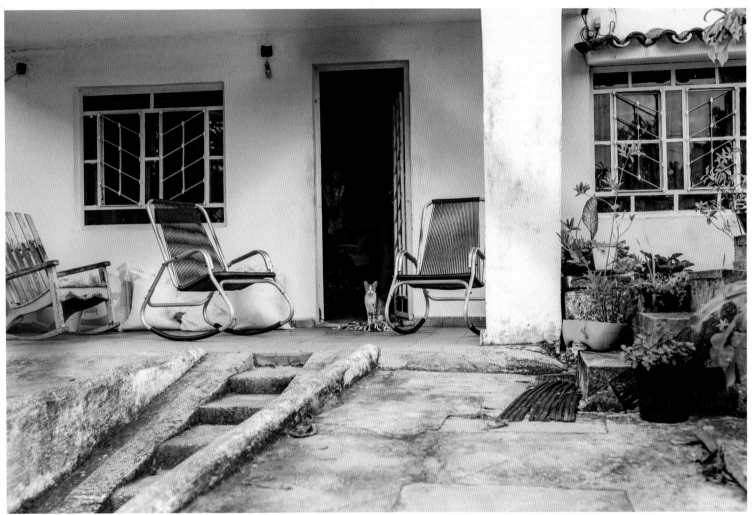

Nueva Gerona, Isla de la Juventud

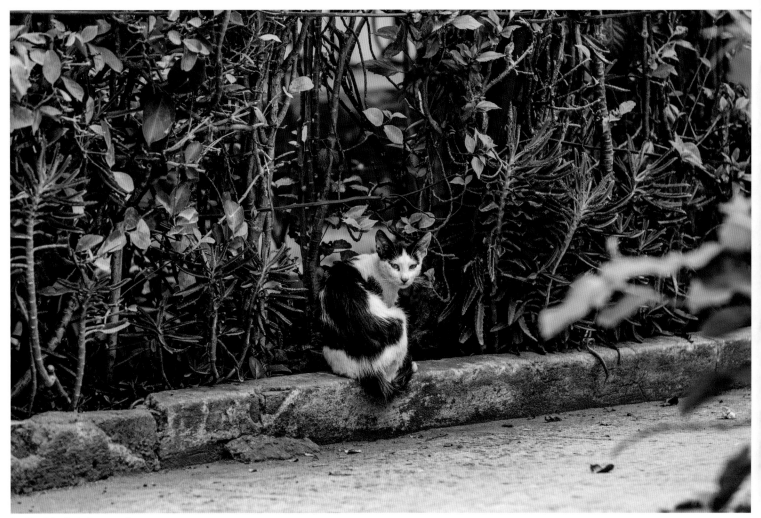

La Fe, Isla de la Juventud

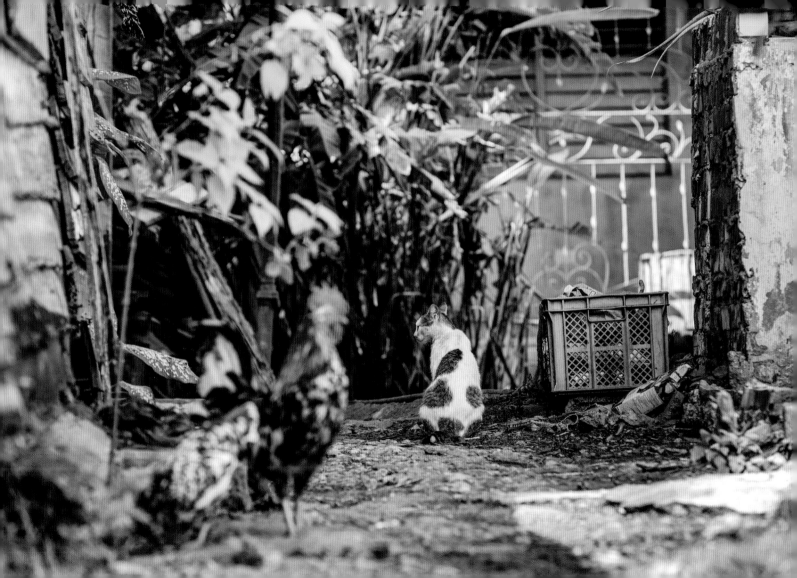

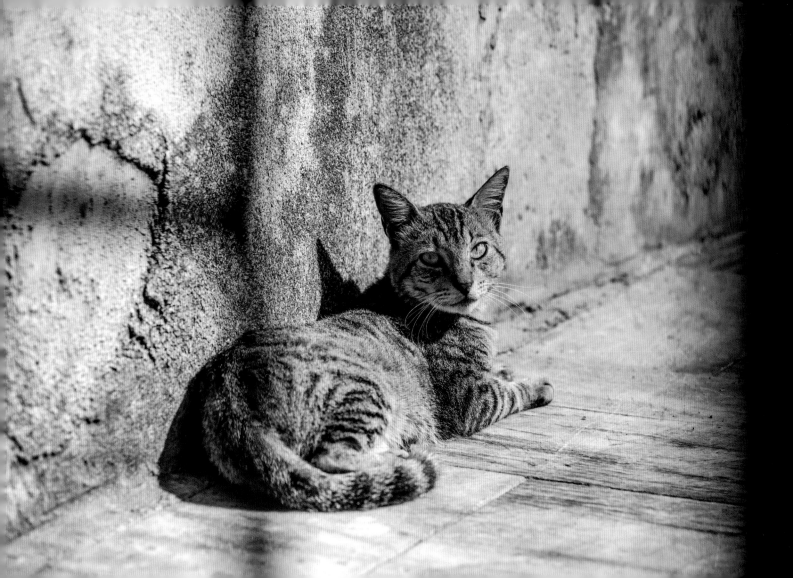

Playa Bibijagua, Isla de la Juventud

Nueva Gerona, Isla de la Juventud

Edited by Kim Grandizio

Type set in Times New Roman
ISBN: 978-0-7643-5802-9

Printed in China

Published by Schiffer Publishing, Ltd.
4880 Lower Valley Road
Atglen, PA 19310
Phone: (610) 593-1777; Fax: (610) 593-2002
E-mail: Info@schifferbooks.com
Web: www.schifferbooks.com

For our complete selection of fine books on this and related subjects, please visit
our website at www.schifferbooks.com. You may also write for a free catalog.

Schiffer Publishing's titles are available at special discounts for bulk purchases
for sales promotions or premiums. Special editions, including personalized
covers, corporate imprints, and excerpts, can be created in large quantities for
special needs. For more information, contact the publisher.

We are always looking for people to write books on new and related subjects. If
you have an idea for a book, please contact us at proposals@schifferbooks.com.